Denali National Park, July 14, 2004

To David

I wish you all the best
climbing the mountains
of your own life, one step
at a time.

Enjoy the journey!

Laura/ Dick

Climb Denali

A Reflective Journey

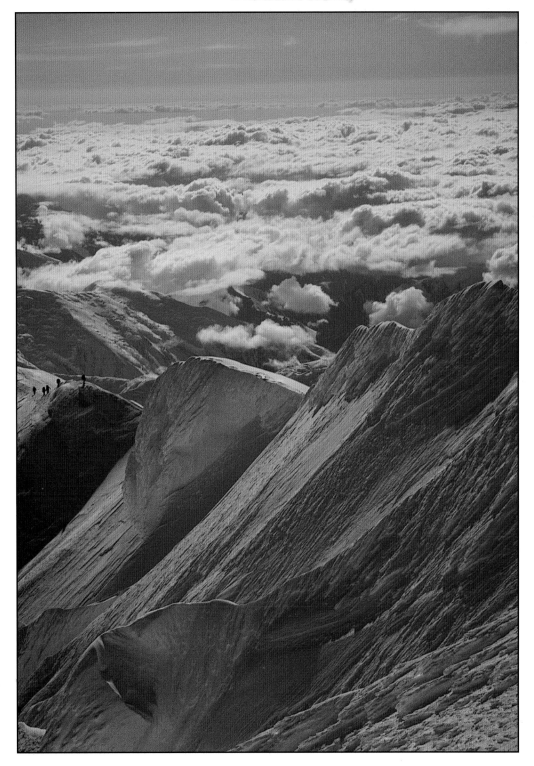

Laurent Dick

In memory of **Karl Nagy.**
Dear Friend, guide and
mentor. (1963-2000)

My deep appreciation to all who generously shared their passion and wisdom for climbing or flying in the Alaska Range and granted me permission to use their voices in this book:

Conrad Anker, climber, Bozeman, Montana (Quote courtesy of KUAC-FM, Fairbanks)
Joanna Cockman, climber, Cantwell, Alaska
Doug Geeting, Talkeetna, Alaska, pilot extraordinaire with over 18,000 hours of flying time around Denali and the Alaska Range
Paul Hwoschinsky, author and photographer, Ashland, Oregon
Dave Johnston, climbing legend and gentle friend, Talkeetna, Alaska
Willie Karidis, executive director, Denali Foundation, Denali Park, Alaska
Kevin Maxwell, master of soulful living and dear friend, Fairbanks, Alaska
Brian McCoullough, guide, Talkeetna, Alaska
Tom Micham, climber, Anchorage, Alaska
Daryl Miller, south district ranger, Denali National Park & Preserve, Talkeetna, Alaska
Brian Okonek and **Diane Calamar Okonek,** Talkeetna, Alaska, legendary guides, who have safely guided expeditions throughout the Alaska Range for many years.
Joe Reichert, mountaineering ranger, Denali National Park & Preserve, Talkeetna, Alaska
Roger Robinson, lead climbing ranger, Denali National Park & Preserve, Talkeetna, Alaska
Kirby Senden, guide, Anchorage, Alaska

My sincere gratitude to those who helped fulfill my vision:

Kris Capps, journalist/Alaska News & Features, Denali Park, Alaska
Willie Karidis, Denali Park, Alaska, who gave me direction when I needed it most
Mike Larsen and **Sheila Bullington,** Todd Communications, Anchorage, Alaska
Charles Mason, professor of photojournalism, University of Alaska Fairbanks
Eric Muehling, multimedia designer, Fairbanks, Alaska
Sue Sprinkle, 5th Avenue Design, Fairbanks, Alaska
Sue Steinacher, fountain of creativity, Nome, Alaska

My infinite love to those who unconditionally gave their support:

My parents **Jean–Pierre** and **Iseut Dick**
My Alaska family **Jerry Stroeble, Mary Leykom, Zoe** and **Alex**
My dear **Greta**

To order additional copies of CLIMB DENALI, to purchase fine art prints of images from this book, or for information about lectures and the multimedia presentation 'Climb Denali', please contact info@laurentdick.com or visit www.laurentdick.com

Printed by Samhwa Printing Co., Ltd., Seoul, Korea
International Standard Book Number 1-57833-247-8
Library of Congress Control Number 2003114486

FOREWORD

Denali's higher slopes remain one of the wildest edges of the earth—a realm of ice, snow and windswept ridges above the clouds. In Climb Denali, Laurent Dick takes us on a journey to this field of dreams where climbers encounter both the dangers of the ascent and the beauty of this great mountain.

When I look back on my days on Denali, I recall with great fondness that ever-shifting light that's so hard to describe to someone who hasn't been up there. It's a joy to find that Dick's photography has captured so many exquisite moments, so many of the moods of the mountain. Tiny ice crystals sparkling in the still air. Soft light of a full moon glistening on the ice. An avalanche thundering down a ravine. A rising wind wrapping the mountain in a blinding inferno of spindrift snow. The high ridges bathed in the warm glow of the evening sun.

Climb Denali is also a window to an inward journey where one encounters both fear and courage—and the incredible joy of being in high places. By weaving the words of those who know the mountain well with images from his own ascents, Dick conveys what it feels like to be up there in the thin air, pushing the limits of body and mind. Leafing through the pages, we begin to see why one would want to take on the rigors and uncertainties of the climb.

More than any book I know, Climb Denali captures what a great adventure it can be to climb one of the most challenging and beautiful mountains in the world.

Art Davidson
Climber and author

Encounter

I climb as I overcome the obstacles in my life, one step at a time, and in climbing, I discover myself. Deep levels of trust, respect and honesty grow between myself and my companions. A connection develops with the lofty cathedrals of rock and ice around me. My spirit moves with the spirit of the mountains. I am uplifted and linked with a powerful life force. At the same time, I am humbled, a tiny snow crystal in the vast expanse of snow and ice.

Laurent Dick

TOP OF NORTH AMERICA – Denali's summit and western flanks rise above an ocean of clouds.

"Imagine this area, before there were any detailed maps, before there was any motorized machinery, before anybody had set foot on the glaciers or been to altitude. It's just amazing to me to try to transport myself back in time and think what it would be like approaching the mountain by thrashing through the brush for weeks, fighting swift moving rivers, not knowing what's coming next." **BRIAN OKONEK**

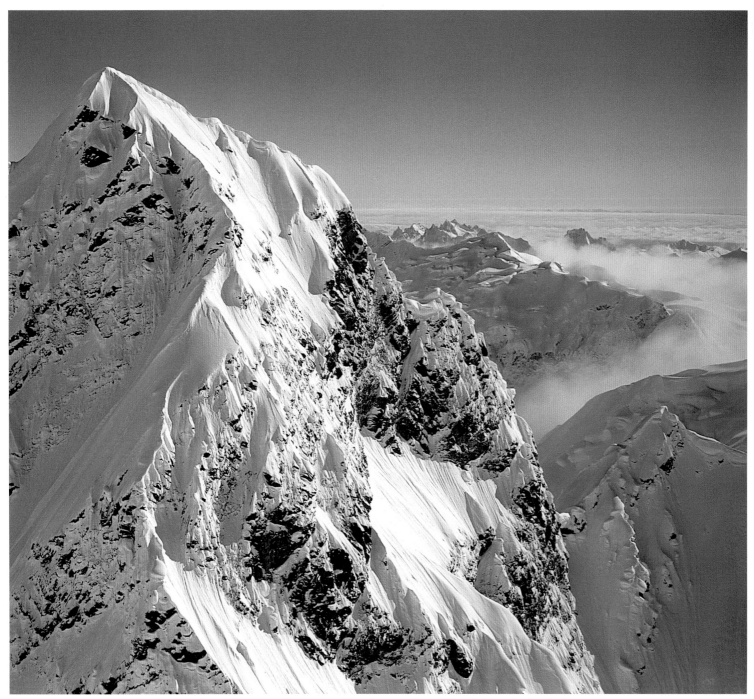

SNOW AND ICE SCULPTURES – The flight from Talkeetna to base camp offers close up views of fluted ridges in the Alaska Range.

"There is nothing more humbling for a pilot then to fly Denali. The landscapes and vistas are like no other on the planet. Denali is most certainly a living, breathing place, creating and spewing out its own weather moods. Whatever the Great Mystery is, it certainly had its hand in the creation of the Alaska Mountain Range." **DOUG GEETING**

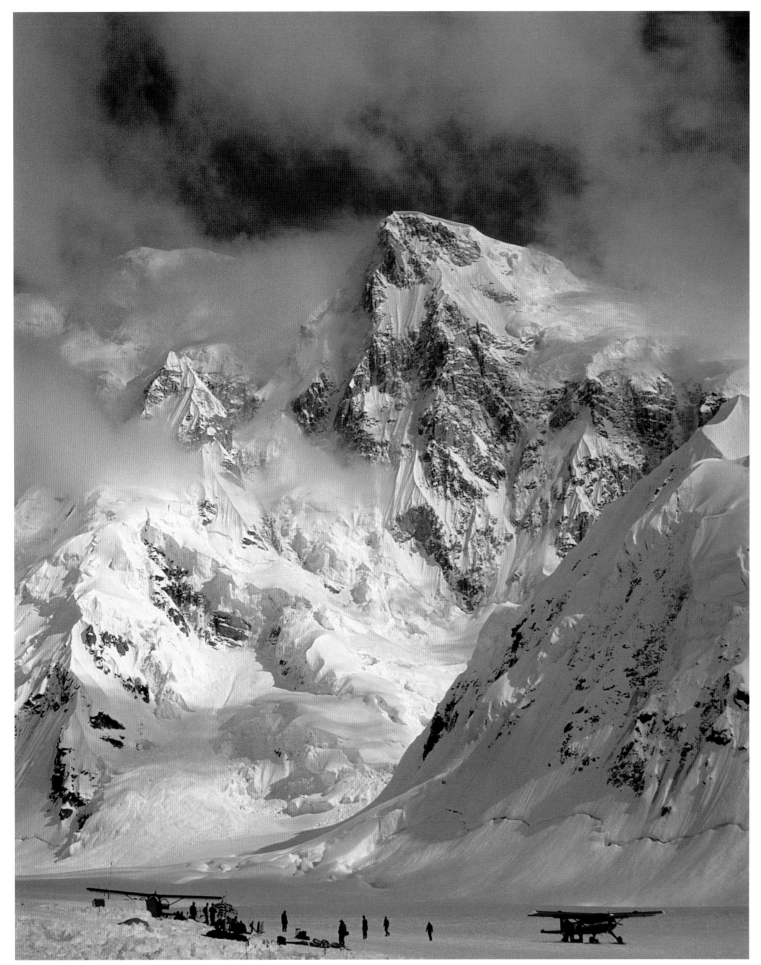

BASE CAMP – Planes park in the shadow of Mount Hunter's North Face, at 7,200 feet, on the southeast fork of the Kahiltna Glacier. Base camp buzzes with activity during the climbing season from May through July. Climbers from all over the world camp here, preparing to ascend or waiting to fly out.

"There are no two flights alike. No glacier landing is the same as the one before. To fly Denali, a pilot must be alert to sudden changes in weather and snow conditions. There is absolutely no room for complacency or lack of attention while flying up there. Sure, it's a great place to work and the views are spectacular, but you gotta pay attention, certainly when it's not a perfect weather day. On the other hand, I find flying in the mountains and operations on glaciers to be one of the safest types of flying. We fly with skis most of the time, and the whole place is one big landing field for the most part. It's really quite safe and the most enjoyable place to fly as long as you exercise safe operating practices." **DOUG GEETING**

KAHILTNA INTERNATIONAL – Planes and tents dot base camp on the Kahiltna Glacier.

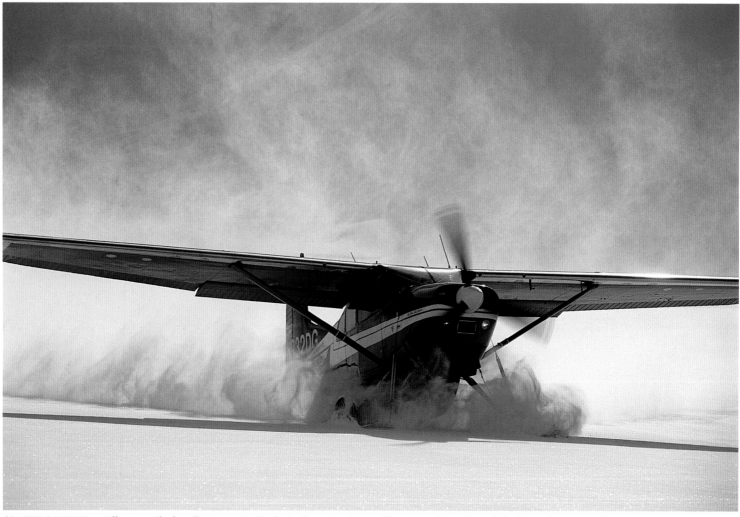

GLACIER LANDING – Talkeetna, Alaska pilot Doug Geeting's single-engine Cessna Skywagon glides through fresh powder snow at base camp.

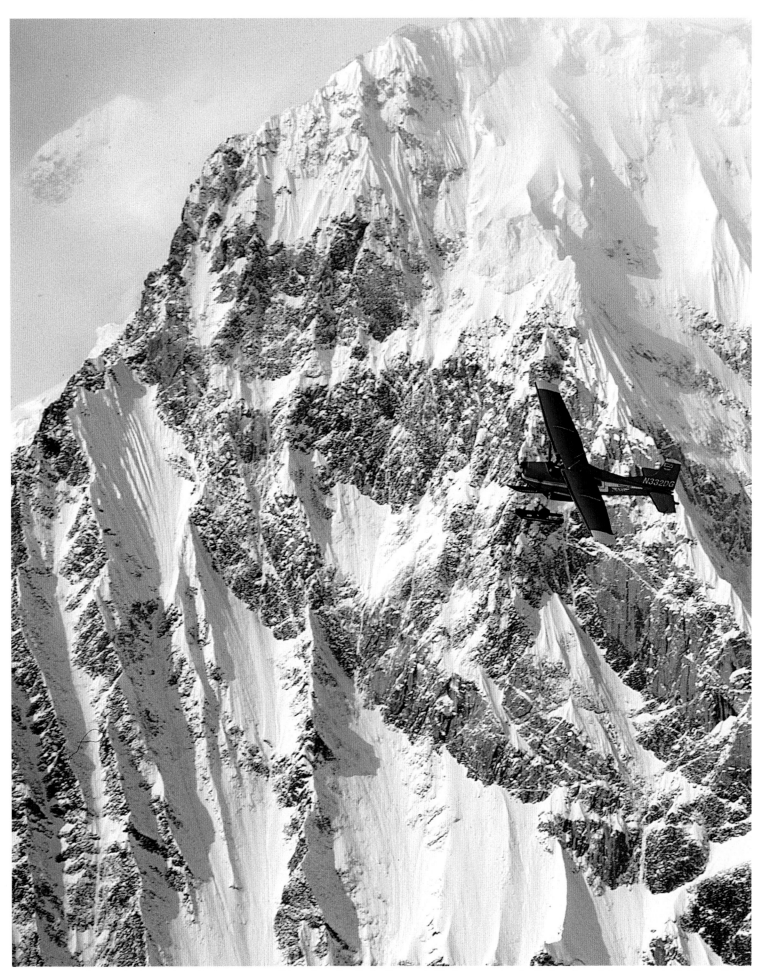

AIR TAXI – Small aircraft play a vital role for most expeditions into the Alaska Range. A ski plane can shuttle climbers from Talkeetna to the Kahiltna Glacier in about 45 minutes, while reaching base camp on foot may take several weeks.

"People can't help but feel they get dropped off and it's like getting out of a taxi. They have this false sense of security. But boy, if that airplane didn't come back to pick them up, a lot of them wouldn't even begin to know how to get out of there. They just wouldn't have a clue what's between them and Talkeetna." **BRIAN OKONEK**

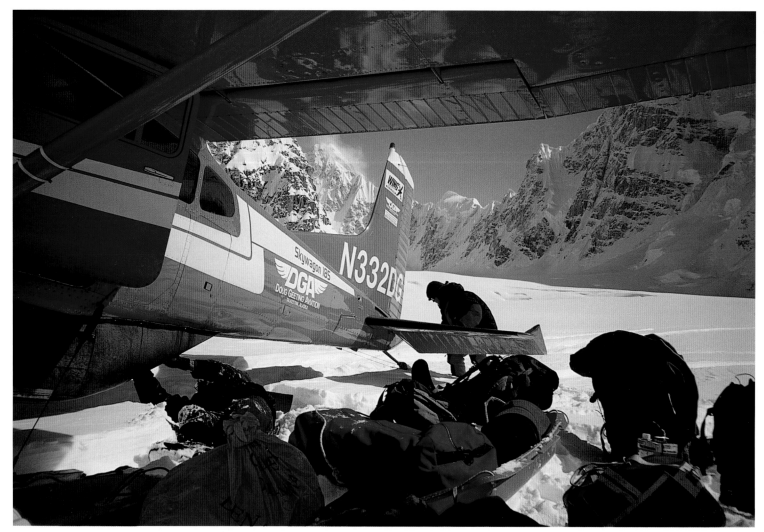

UNLOADING SUPPLIES – The average weight of food, fuel and gear for a three-week-long expedition can easily reach 100 pounds per person.

"I arrived at base camp cocky and feeling in full control over my life. Every decision I made was based on a well thought-out plan and I was in control. But the moment that plane took off, I was standing there in this very foreign environment, in which I was in control of almost nothing. It was quite a stark change from the paradigm I had lived in all my life up to that moment. Getting used to a feeling of insignificance and accepting it as the natural order of things was the biggest change for me." **KEVIN MAXWELL**

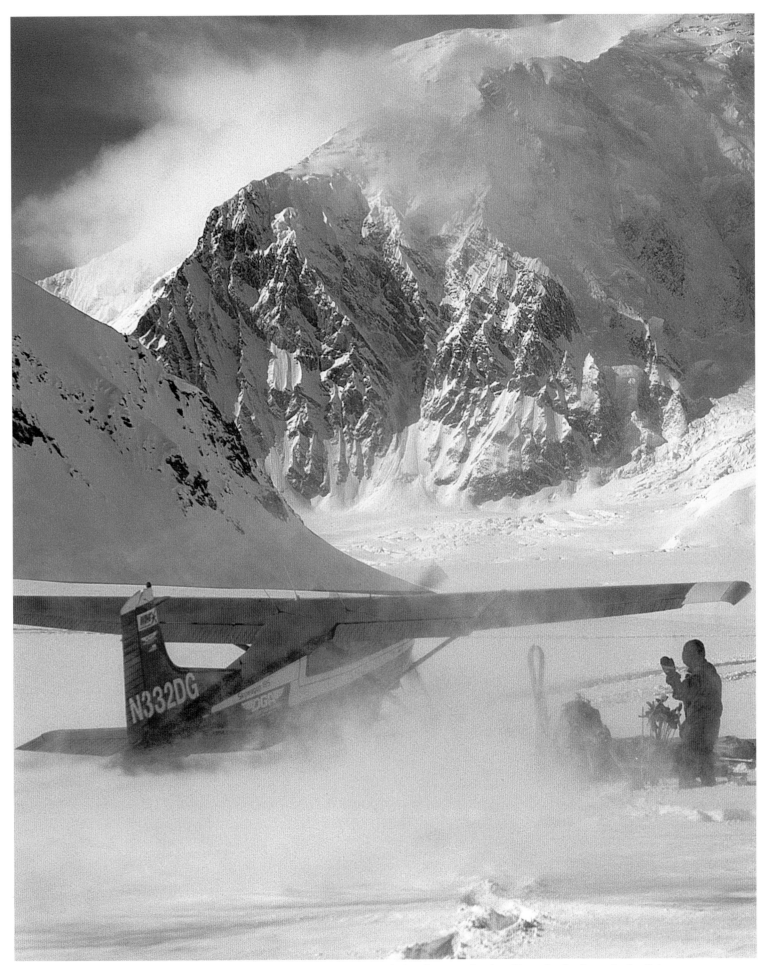

TAKING OFF – Carol Stewart of Fairbanks, Alaska waves farewell to Talkeetna, Alaska pilot Doug Geeting. Mount Foraker looms in the distance.

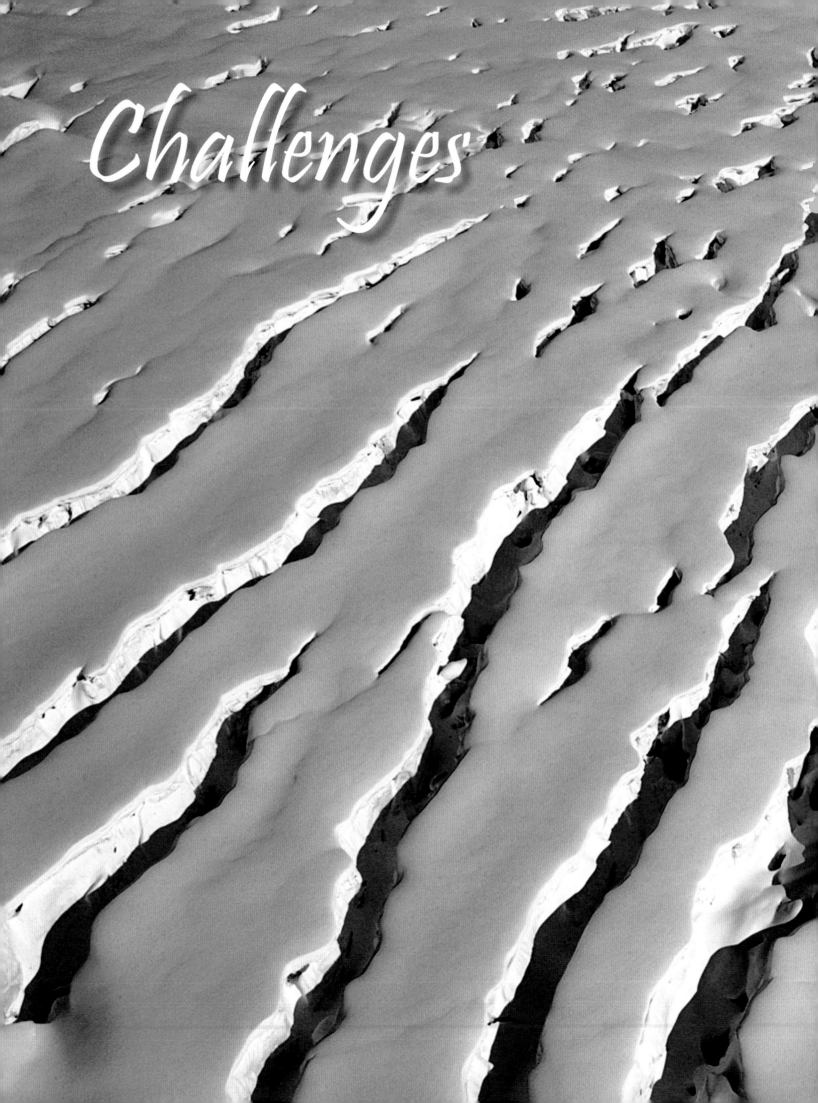

Challenges

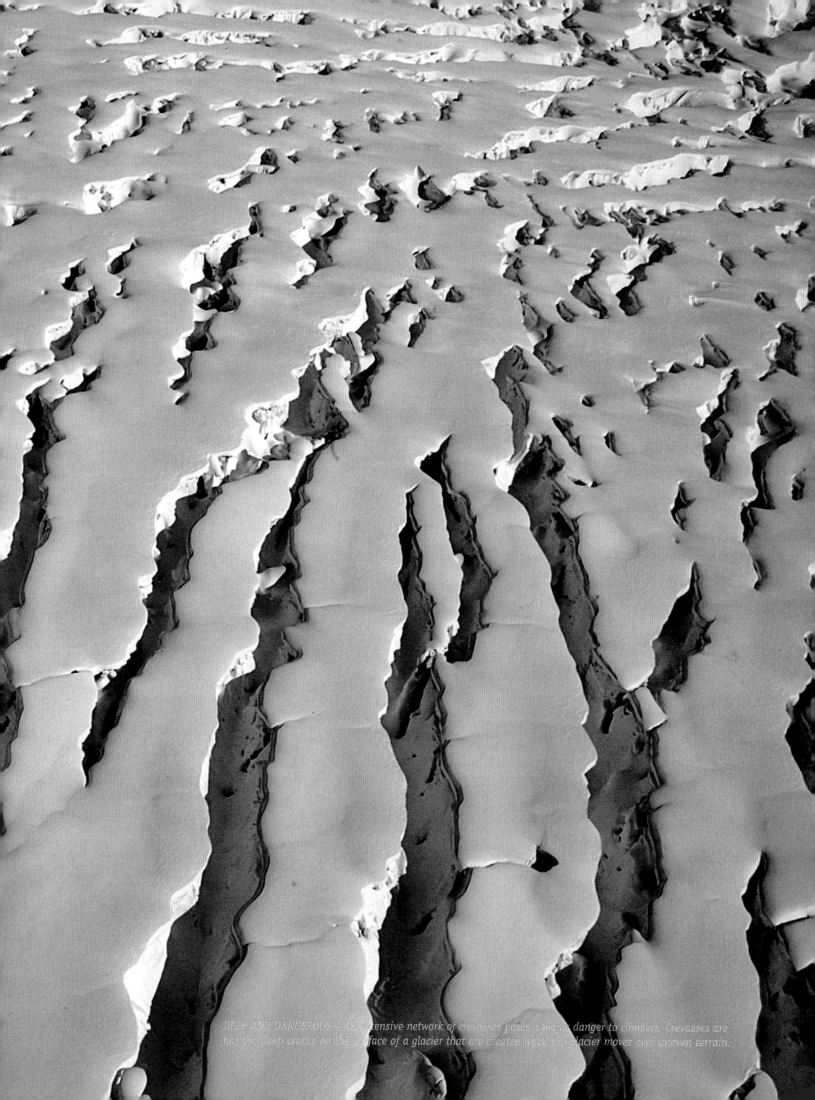

DEEP AND DANGEROUS – An extensive network of crevasses poses a major danger to climbers. Crevasses are narrow, deep cracks on the surface of a glacier that are created when the glacier moves over uneven terrain.

"Technology allows people to climb faster and even safer, but sometimes it promotes a false sense of security, especially when people make decisions based on technology such as cell phones or radios rather than what they can really do physically. The best and lightest tool that you have is your judgement." **DARYL MILLER**

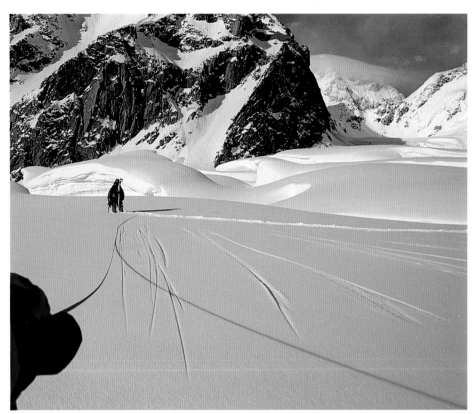

SAFETY FIRST – Roping up is essential for safety as climbers navigate crevasse fields.

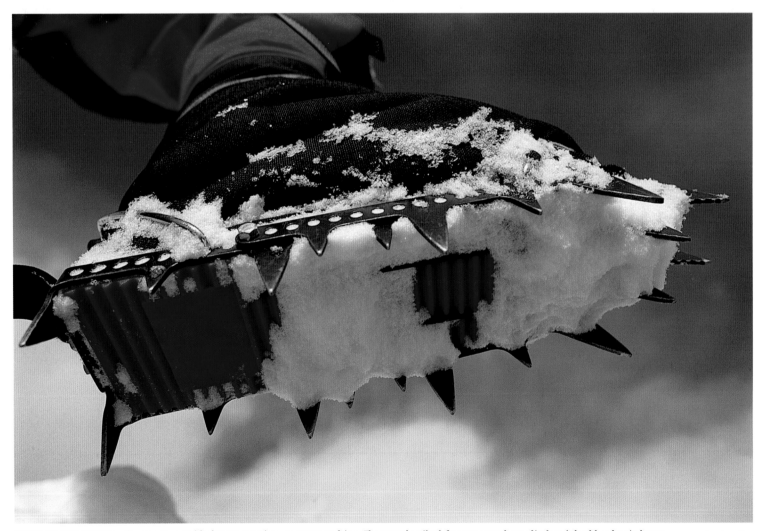

TOOLS OF THE TRADE – Crampons provide better traction on snow and ice. The metal-spiked frames attach to climbers' double-plastic boots.

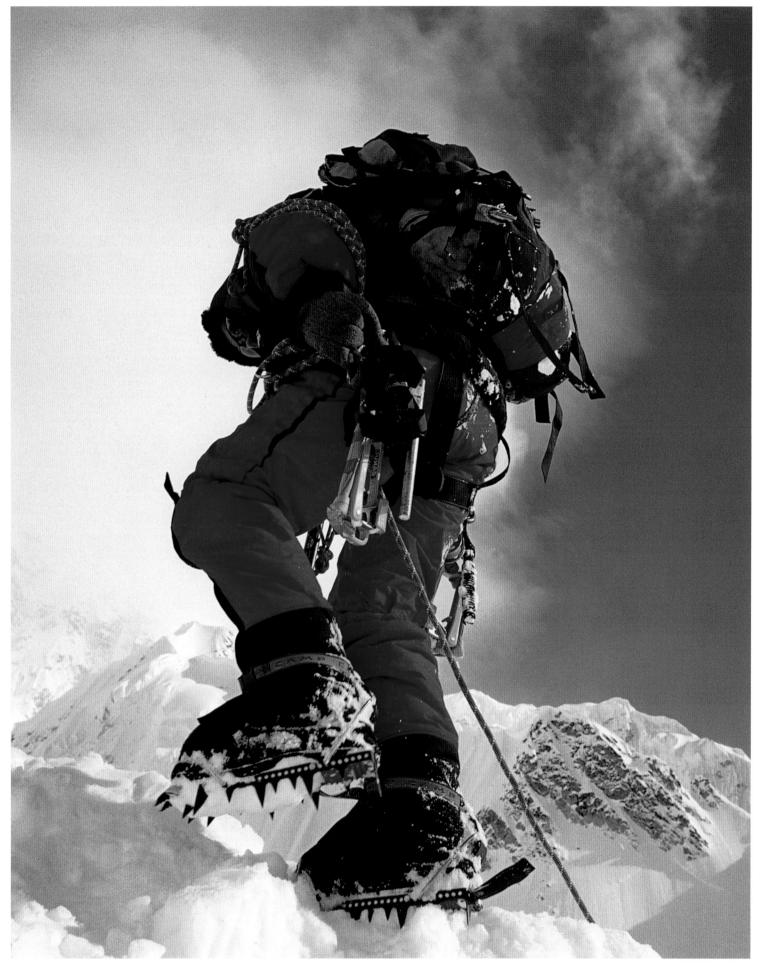

FIRST STEPS – Carol Stewart of Fairbanks, Alaska moves up the mountain one step at a time. Climbers use skis or snowshoes on the lower mountain, before trading them for crampons to ascend the upper mountain.

"It's a lot of work. You are just working so hard sometimes, you know, with the pack on, and the snow is deep, and you are wading up to your knees. And you're just working like a dog." **BRIAN McCOULLOUGH**

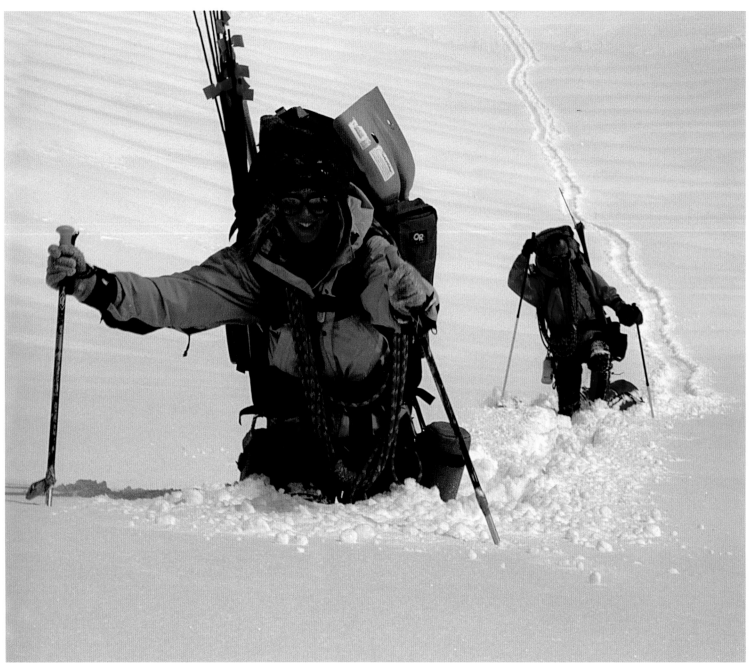

TRAIL BREAKERS – A roped team blazes a trail through waist-deep snow near the bottom of Motorcycle Hill at 11,000 feet.

"Pacing is of utmost importance. You've got to do things slowly enough that you can breathe in enough air mass to keep your muscles saturated with oxygen. If you go too fast, very quickly you will be in oxygen debt. You're gonna have to stop and catch your breath, your muscles will get so heavy you won't be able to move. You won't be able to lift your foot a second time." **BRIAN OKONEK**

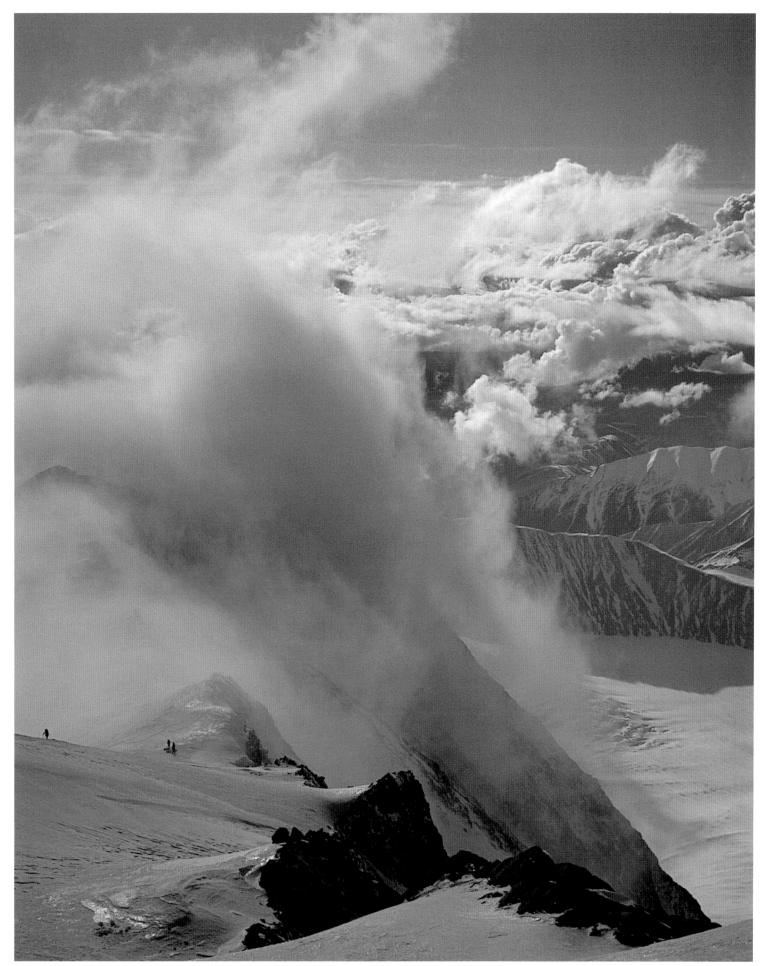

MOVING UP – Climbers break trail on top of Motorcycle Hill at 12,000 feet on the West Buttress Route. This route is about 15.5 miles long from base camp to the summit. It is the most frequently climbed route on Denali, attracting more than 1,000 climbers each year.

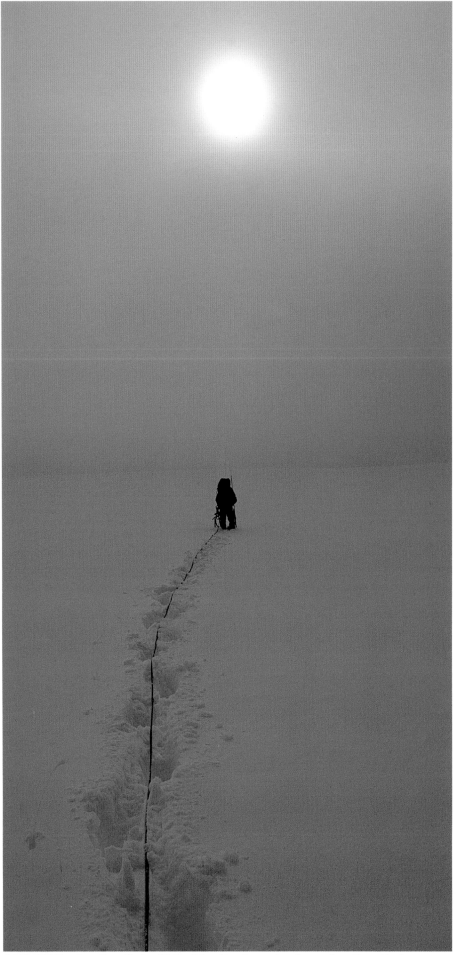

"You are always thinking ahead, thinking about that hidden crevasse that might swallow you up. You are often looking for the huge crevasses, but interestingly it's the little ones that can cause you the problems — the ones that are only three to four feet wide. They can swallow you and your whole team if you go at it at the wrong angle." **ROGER ROBINSON**

"Roping up might save your life, but the rope also represents a bond of mutual trust and respect. As you cross huge crevasse fields on the glacier, you think of safety and the responsibility you have to your climbing partners." **LAURENT DICK**

PATHFINDER – Canadian climber Michael Engelhardt searches for a safe path on the lower Kahiltna Glacier. Flat lighting makes route selection difficult.

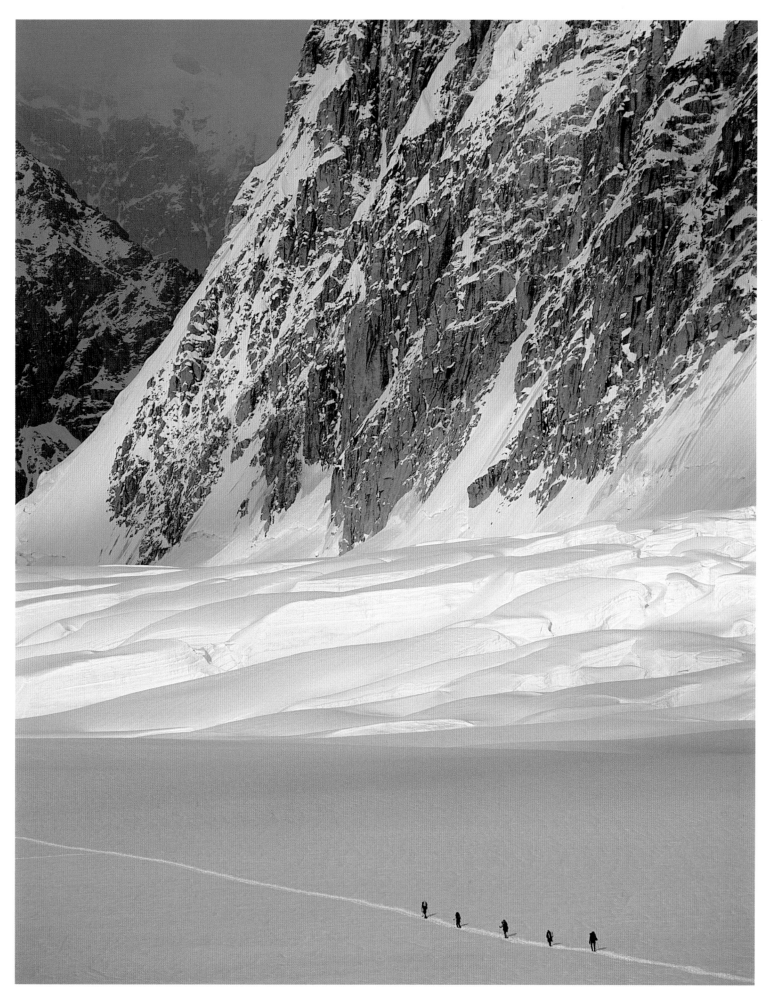

ROCK CATHEDRAL – Denali's vast granite base dwarfs a group of climbers as they move up the northeast fork of the Kahiltna Glacier. To lighten their loads and to allow for proper acclimatization, climbing parties usually double carry – hauling half a load up to a new camp, returning to a lower camp to sleep, then reclimbing the next day with the rest of the gear.

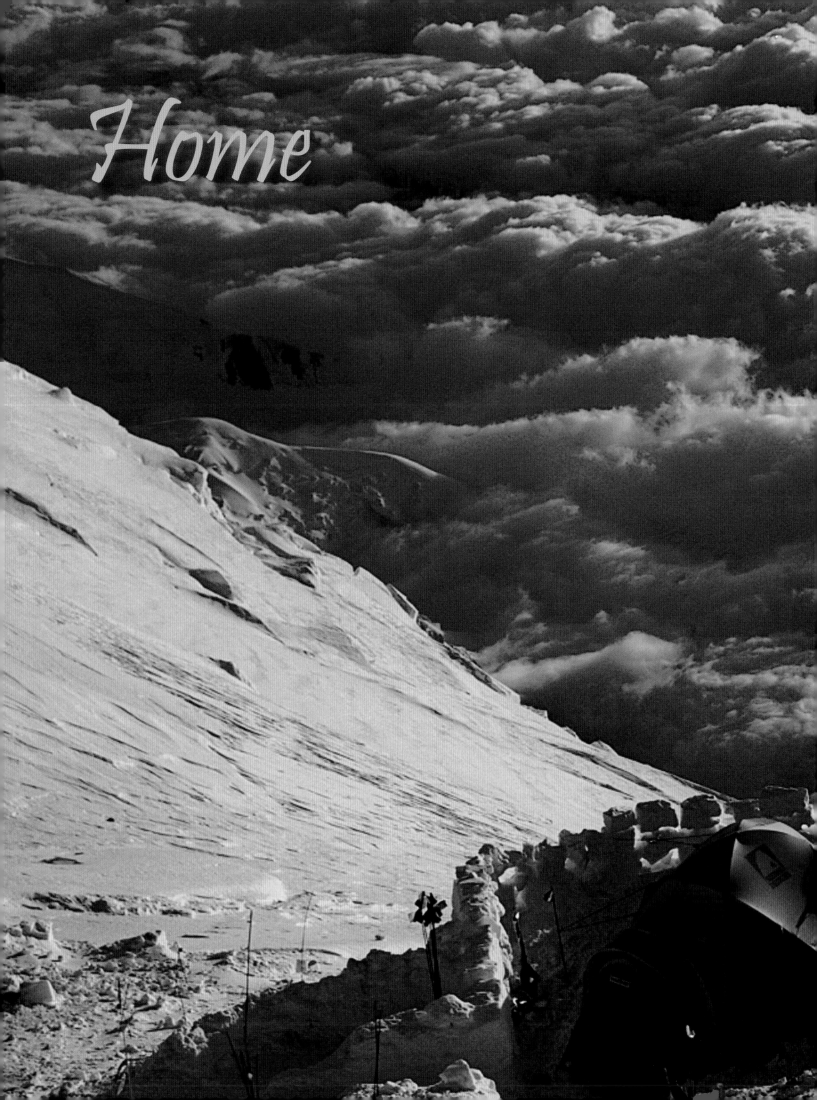

Home

ROOM WITH A VIEW – Many climbers stranded in bad weather recall harrowing experiences at this exposed camp at 16,000 feet.

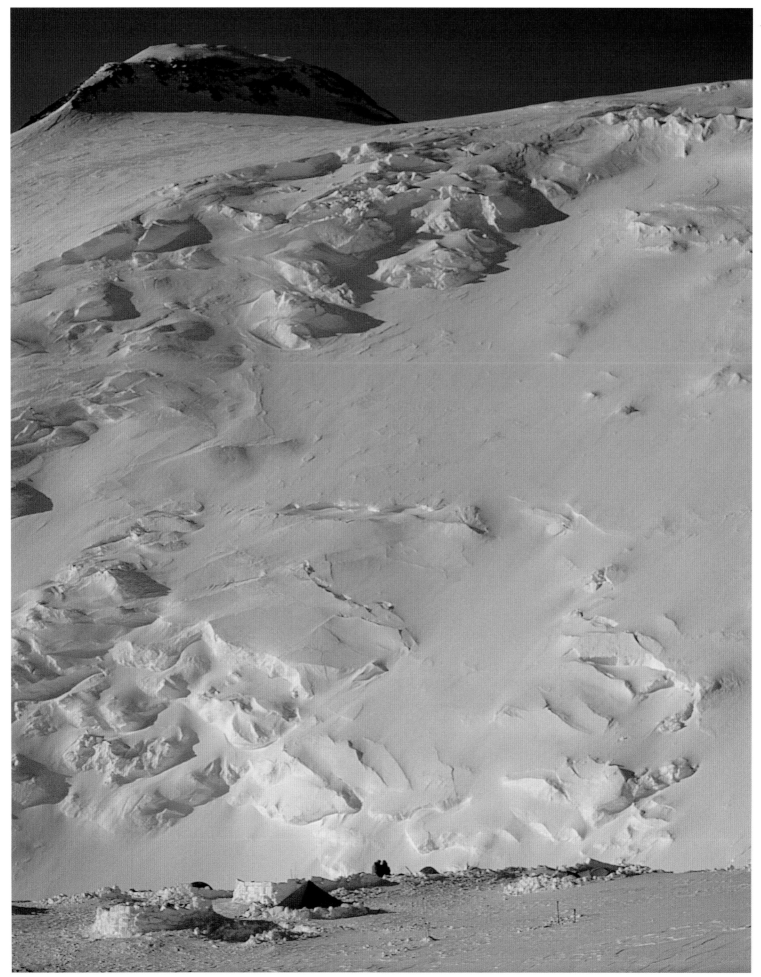

SNOW FORTRESS – Climbers build snow walls to protect their tents from ferocious winds that frequently blast the 17,200-foot camp on the West Buttress.

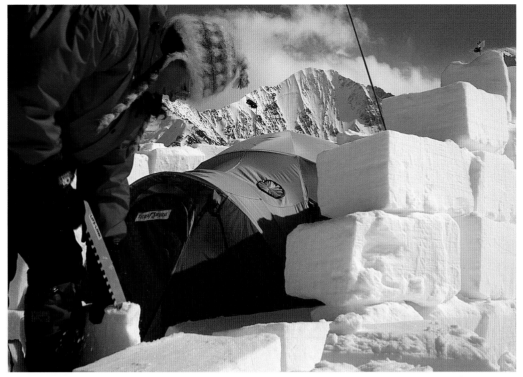

"If you know how to camp in the cold and are patient, you've got it made, at least on the easier routes. You can't be in a big rush, or you will get in trouble if you push when you shouldn't. There are times up there when you can't get too cocky, no matter how good a climber you are. You are going to get your old tail kicked if you go out." **DAVE JOHNSTON**

SNOW CARVER – Willow Jones of Santa Cruz, California uses a snow saw to cut snow blocks.

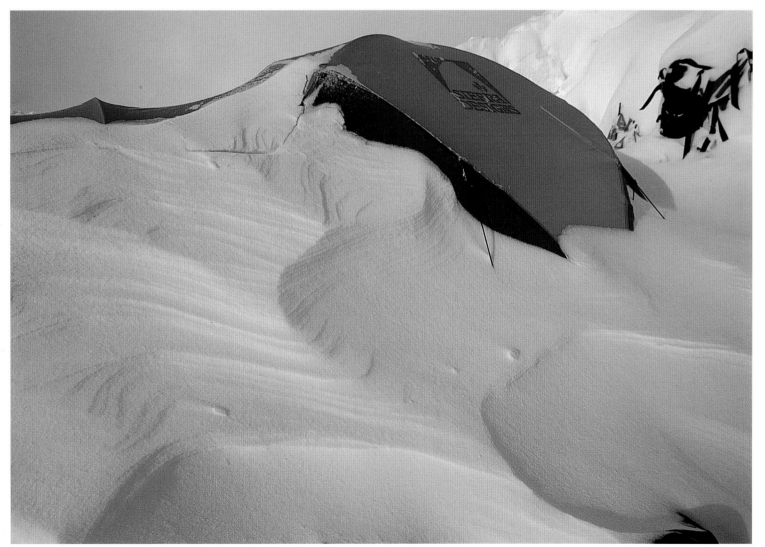

STORMBOUND – A tent is buried in snow after being pounded by high winds and snow.

"There is a notable difference between a gamble and a calculated risk. A calculated risk considers all the odds, justifies the risk, and then makes an intelligent decision based on conservative judgment. A gamble is something over which you have no control and the outcome is just a roll of the dice." **DARYL MILLER**

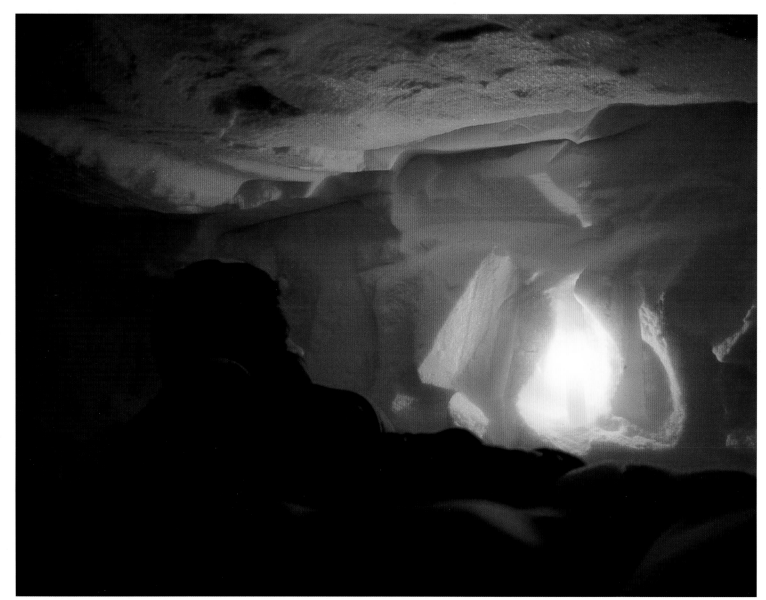

SAFE HAVEN – Candlelight illuminates a snow cave and provides added warmth to climbers stormbound on the mountain. A snow cave can mean the difference between life and death during a storm.

"We were in this crevasse for eight days. Toward the last days, we had almost completely run out of food and we used up most of our candles. We would wake up some mornings and you'd put your hand up above your face you'd find the roof of the snow cave had compressed and it had come down eight, ten, or twelve inches, and you didn't even have enough headroom to sit up in your sleeping bag. There was a claustrophobic feeling of the roof of the snow cave coming down. We were thinking, gosh, if that happens we're gonna be snuffed out and nobody will have any idea where we are." **TOM MICHAM**

"A hundred years ago wilderness survival skills were a way of life in Alaska. The rule was simple and harsh: Survival was your responsibility and no one else's. We have grown socially and culturally unwilling to accept that primitive education which dictated that people simply learned or died." **DARYL MILLER**

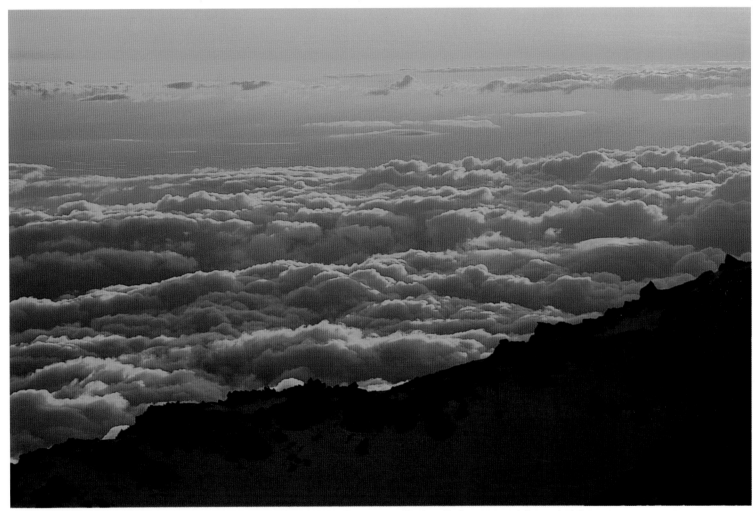

LUMINESCENCE – The midnight sun graces the northern slopes of Denali in June, allowing climbers to travel day and night.

"Today, because most people, including most Alaskans, live in urban environments and grow up within an urban culture, wilderness skills are never learned. The result is that the wilderness-bound end up depending more and more on equipment and less and less on their own competence to deal with dangerous situations in wilderness settings. Most forget that the most important trip objective and priority is a safe journey out and back." **DARYL MILLER**

"We had pretty much read everybody's book. We had read all the labels on the food wrappers. We had to start rationing our food and fuel. We had one hot meal a day. We had to go back through our trash, and we picked through to find scraps of food. This lasted for seven days before the weather cleared. The hardest part was that we were going stir crazy after moving eighteen days in a row, and now we were sitting dormant for a whole week." **KIRBY SENDEN**

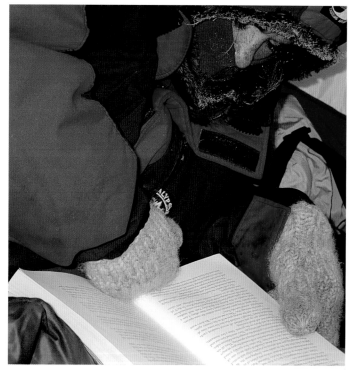

WELCOME DISTRACTION – Carol Stewart of Fairbanks, Alaska reads a book in subzero temperatures.

WELL-EARNED REST – Willow Jones of Santa Cruz, California seeks warmth from temperatures of 30 degrees Fahrenheit below zero on the Muldrow Glacier.

"Climbing is getting back to the basics that really count. You simplify life and have a common objective with your teammates. You eat, you sleep, and you go up or down. If it's lousy weather, you get to lie in bed and read without feeling guilty at all, and that's wonderful." **DAVE JOHNSTON**

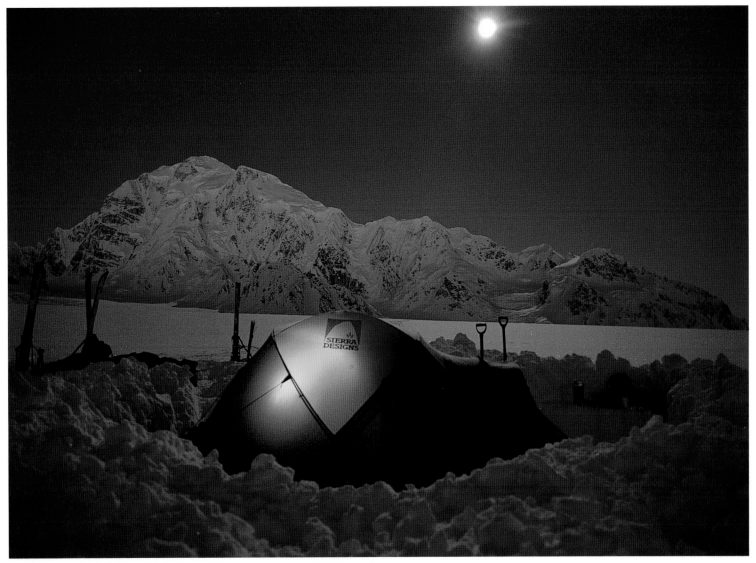

MOONRISE – A full moon illuminates a camp on the lower Kahiltna Glacier.

"You've got one focus. So often, at home, there's so many different things happening all the time. You are juggling family affairs, business affairs, the phone's ringing, there's bills to pay and on and on. On the mountain, you get down to bare basics." **BRIAN OKONEK**

Humbled

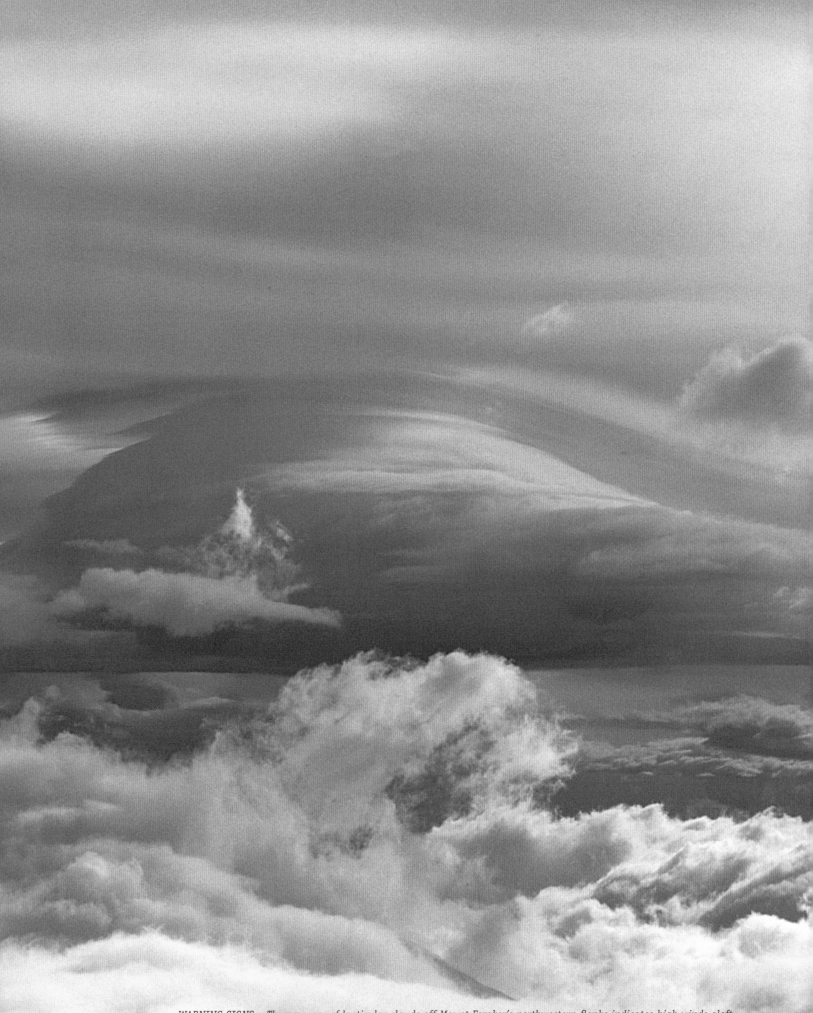

WARNING SIGNS – The presence of lenticular clouds off Mount Foraker's northwestern flanks indicates high winds aloft.

"It humbles me every time I go up there. Just go and see some shopping mall-size avalanches come whooping down. Just bang! Then you look up where it came from. The thing dropped like 5,000 feet and you can't even tell, I mean, it could do it again. All these city blocks could fall off this mountain and it's not gonna look different." **BRIAN McCULLOUGH**

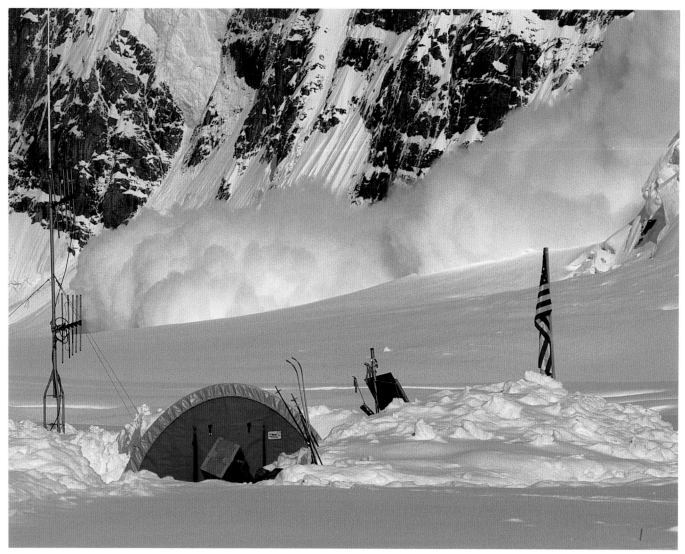

TOO CLOSE FOR COMFORT – A powder blast plows its way toward the National Park Service base camp on the southeast fork of the Kahiltna Glacier.

It's just not the same as climbing down in the Cascades or the Colorado Rockies. It's not until people get on the mountain that it hits them. The scale is just so much greater. It's definitely on the scale of Himalayan-type climbing." **ROGER ROBINSON**

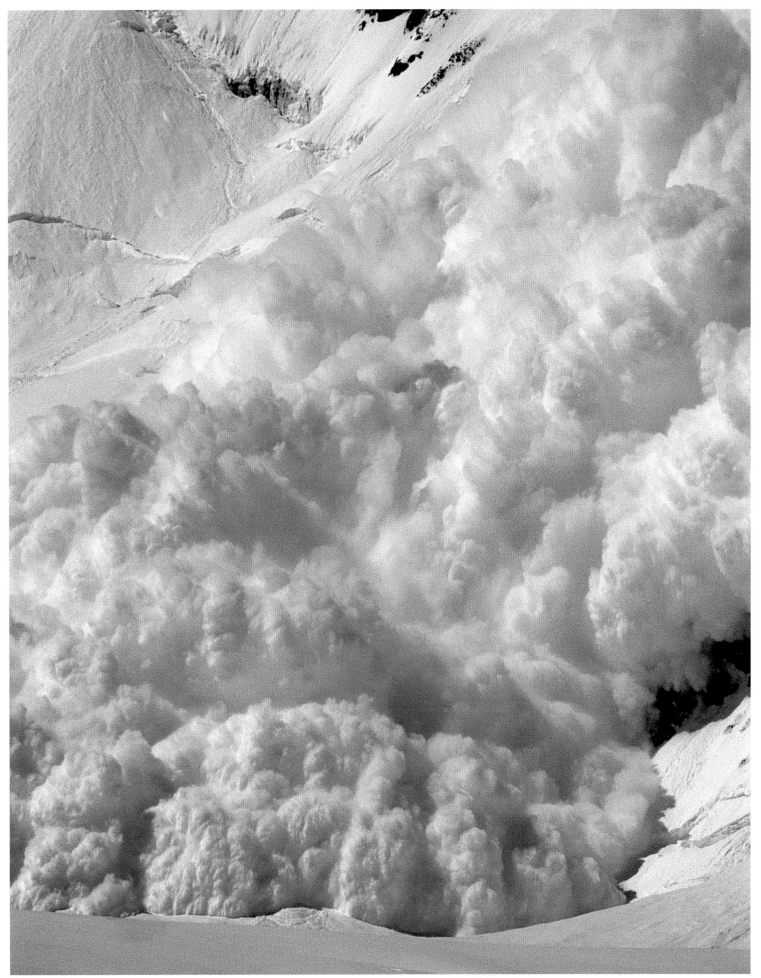

MONUMENTAL FORCE – An avalanche originating on Mount Foraker's steep slopes pours onto the Kahiltna Glacier.

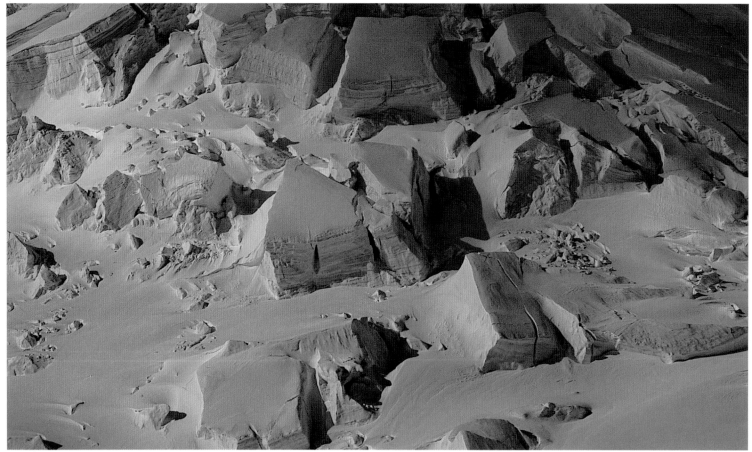

GLACIAL SCALE – House-sized blocks of glacial ice called seracs form where the glacier surface is fractured.

"You can't help but feel an incredible presence of natural forces at work up there, that are so much larger than yourself. It's a living entity, not just a pile of inanimate rock, snow and ice. This whole mountain world is in constant flux, avalanches roaring down, seracs breaking off — it's just amazing to see this environment on a scale barely conceivable to the human mind." **LAURENT DICK**

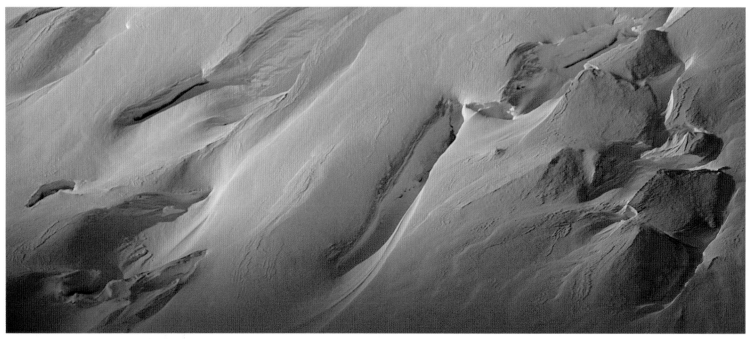

HAZARDOUS TERRAIN – Snow bridges often cover crevasses, rendering them nearly invisible to climbers.

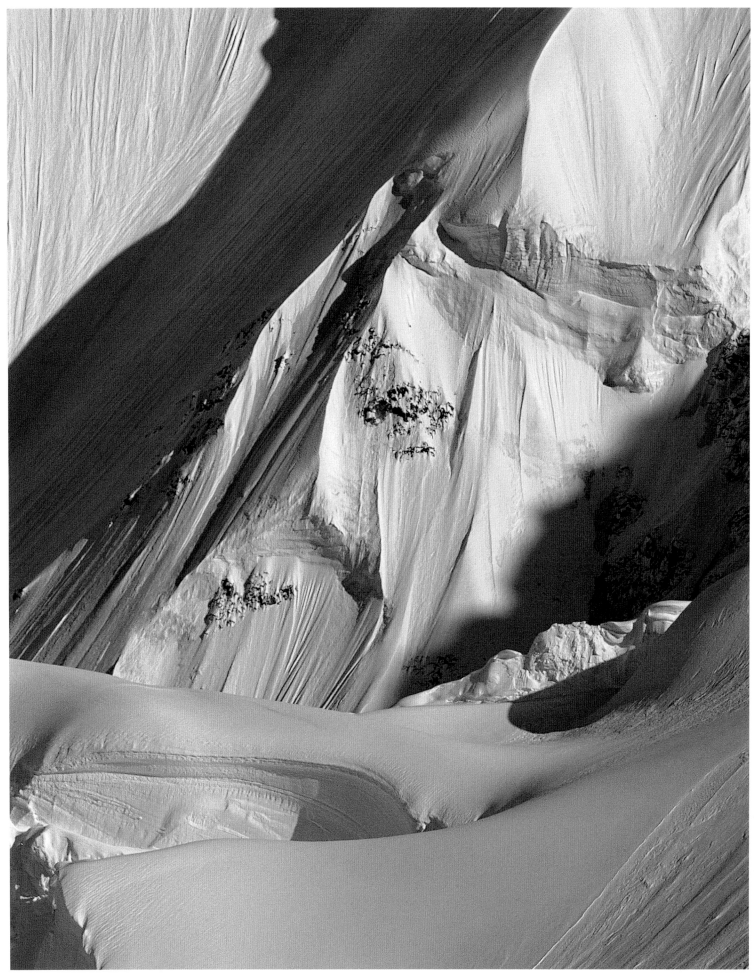

NATURE'S DESIGN – Fierce winds are the sculptors of Denali's impressive icescapes.

"Being in a storm on Denali is a very uncomfortable position for most people to be in because their whole life they feel like they are in control. Then... they get on Denali. They get caught in a storm, and it's very humbling to just be sitting there, wondering what's gonna happen next, trying to keep their act together." **DIANE CALAMAR OKONEK**

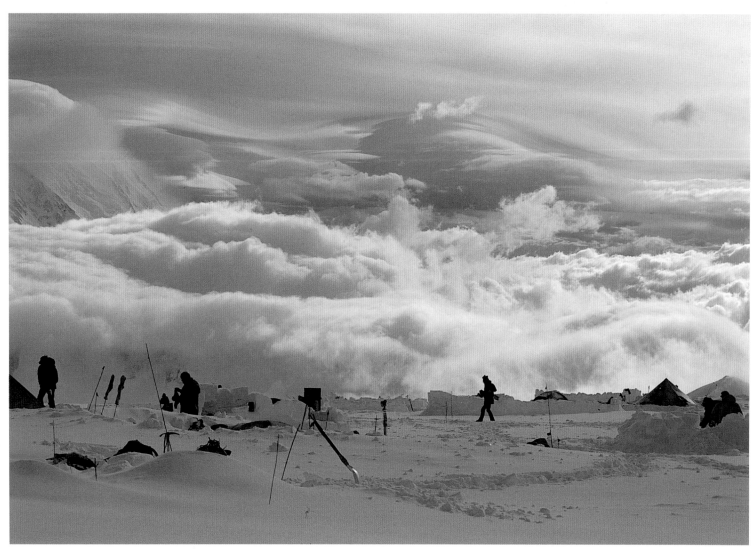

DIGGING IN – The 14,200-foot camp bustles with activity as a storm approaches from the southwest. All West Buttress expeditions use this camp to adapt to the altitude and as a staging area for ascending the upper mountain.

"You have to work with the mountain and make sure you obey the weather, because it's so unforgiving up there. Denali doesn't care about your ticket schedule. Denali doesn't care about your health. Denali doesn't care about your resume, and for sure, it doesn't care who you are." **DARYL MILLER**

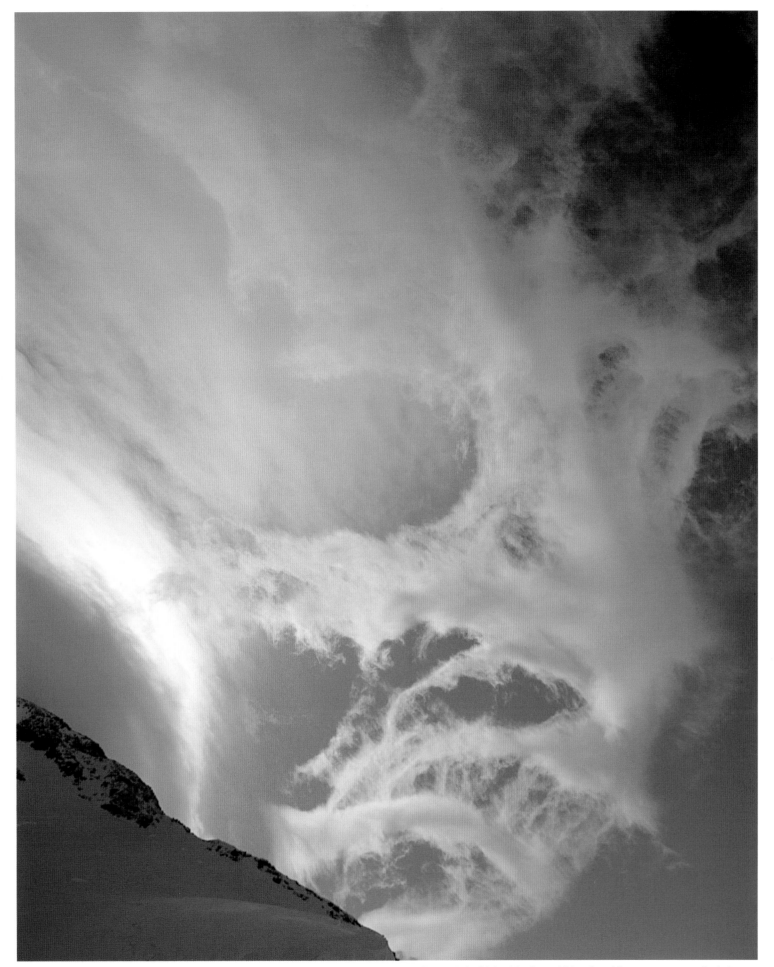

OMNIPOTENT WIND – Denali is so massive that it creates its own weather. Hurricane-force winds, high altitude and bitterly cold temperatures make it home to one of the most extreme climates on earth.

Glimpses

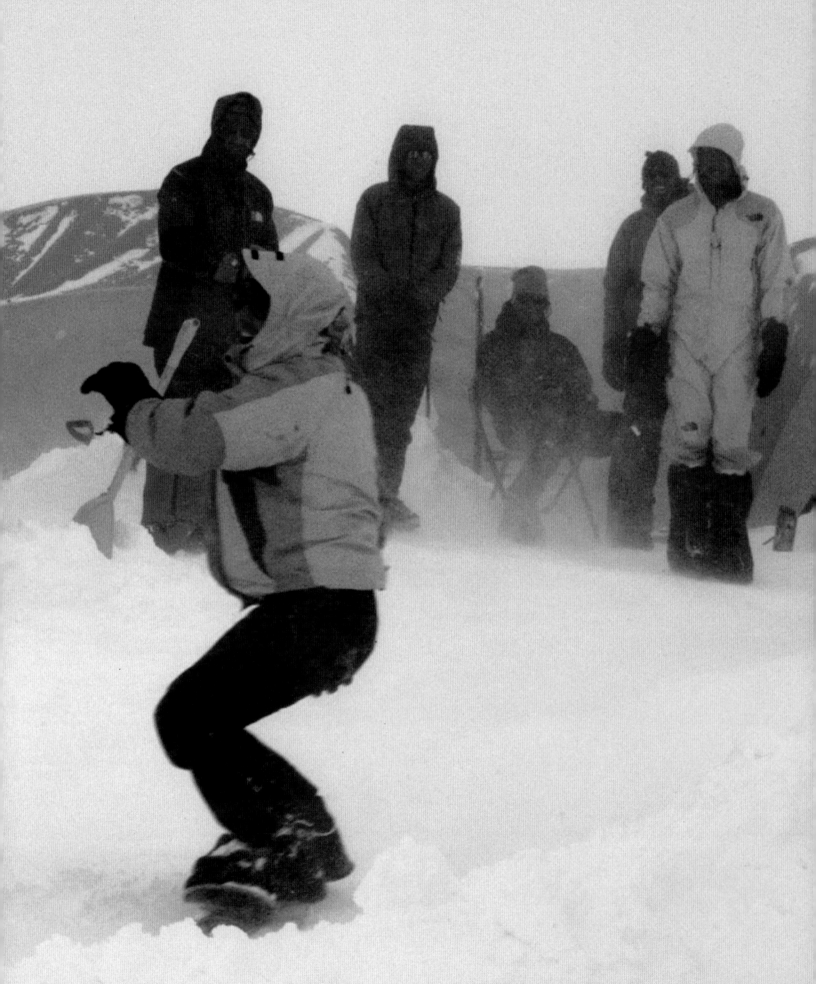

WELCOME DISTRACTION – Mountain guide Doug Workman of Jackson Hole, Wyoming snowboards at 14,200-foot camp, while waiting out a storm.

"The winds were gusting probably 80 miles per hour. I couldn't breathe with my face in the wind, obviously, and I couldn't breathe away from the wind because the wind was taking the air out of my mouth...it took me every bit and all the determination to crawl back to the tent on my elbows and my knees. My hands, I couldn't feel them. The wind will unmercifully kill you on Denali." **DARYL MILLER**

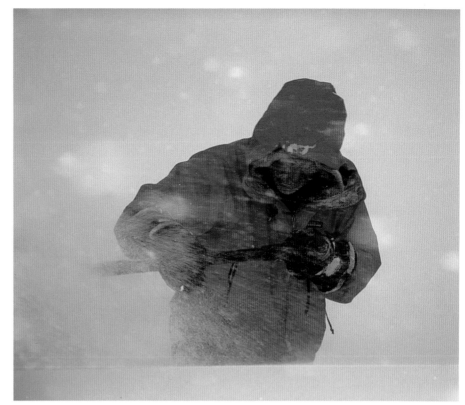

WHITEOUT – Pete Monte of Portland, Oregon confronts the elements at 14,200 feet.

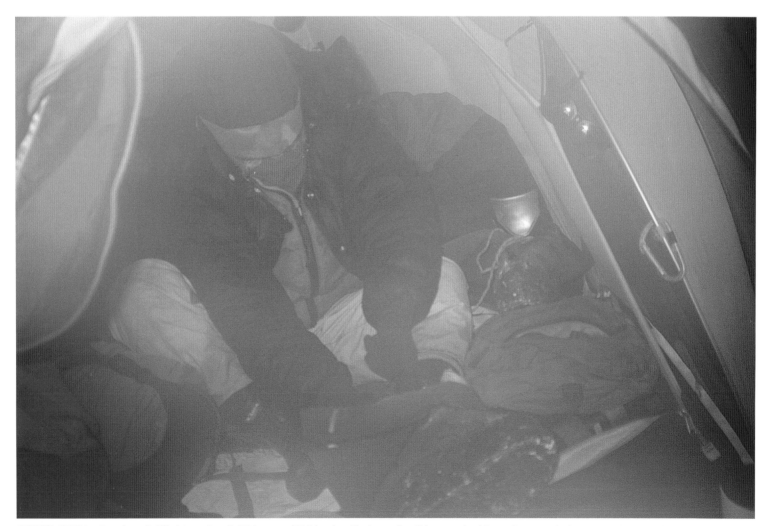

STAYING WARM – In a breath-filled tent, Randy Waitman of Fairbanks, Alaska peels off layers of cold-weather gear before retreating into his sleeping bag.

"The mountain is unforgiving. You have to be prepared for the elements and never rush into a situation, whether you are on the climb itself or on a rescue operation. It's not just flying in, grab the victim and fly back out. There's a lot of mental preparation and pre-planning before we do any rescues." **ROGER ROBINSON**

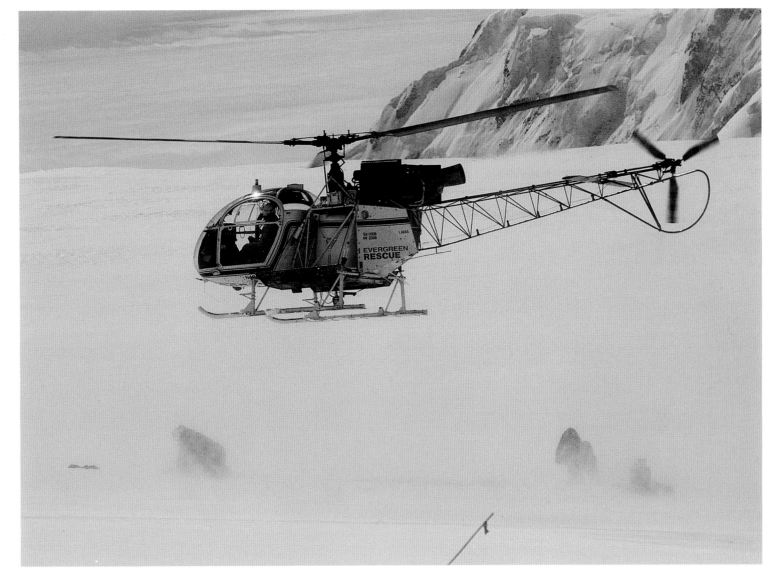

RESCUE MISSION – A Lama helicopter picks up rescuers at 14,200 feet. The National Park Service uses the helicopter for high-altitude rescues on Denali.

"Getting into accidents in the wilderness are like bad relationships — they typically are easier to get into than to get out of." **DARYL MILLER**

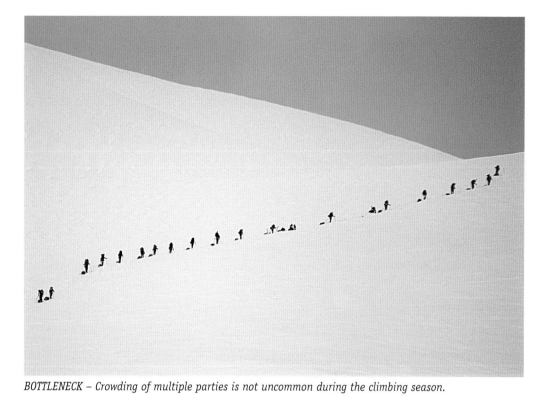

"It's very important for a person to respect what the mountain is, and respect how we can change a place. Just our being there changes it. We need to respect all of those who will follow us by using low impact techniques, leave the fewest traces of our passing and by treating the mountain with as much reverence as possible. As more and more of us climb, this becomes more and more important." **BRIAN OKONEK**

BOTTLENECK – Crowding of multiple parties is not uncommon during the climbing season.

SOCIAL HOUR – Climbers mingle in bone-chilling cold at the 14,200-foot camp. Most parties stay at this camp for several days to adjust to the altitude.

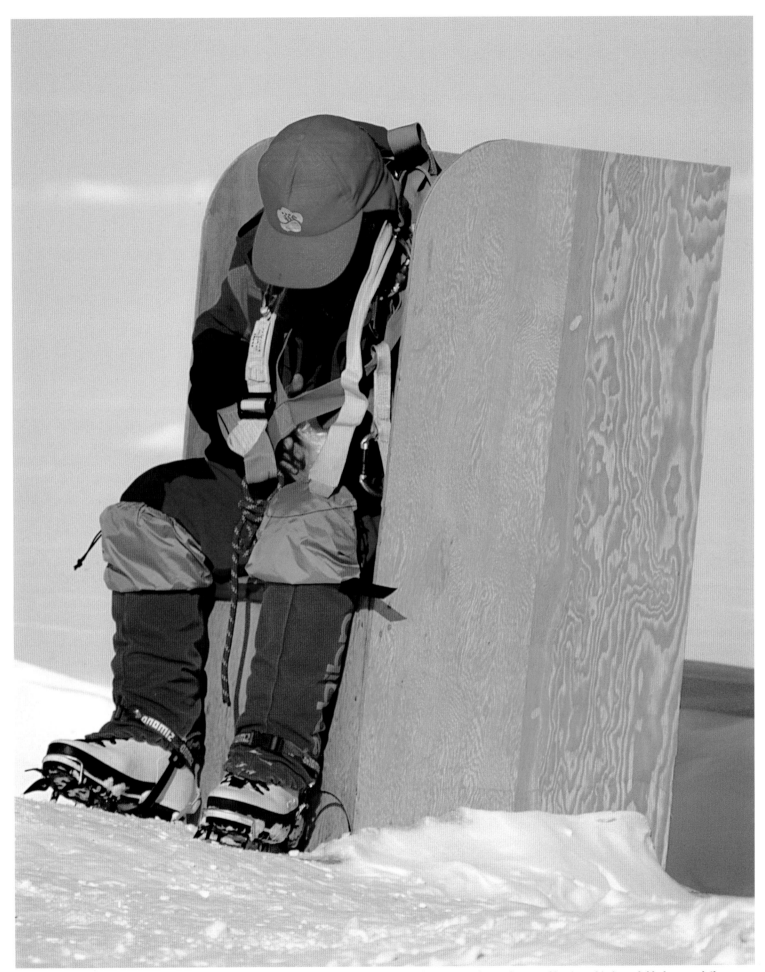

BARE ESSENTIALS – Human waste is a serious issue on the mountain. The National Park Service enforces the use of latrines, biodegradable bags and Clean Mountain Cans to minimize snow contamination from human waste.

Cloudwalking

OUT OF THE CLOUDS – A roped team emerges from the clouds on the Polo Field at 12,500 feet on the West Buttress Route.

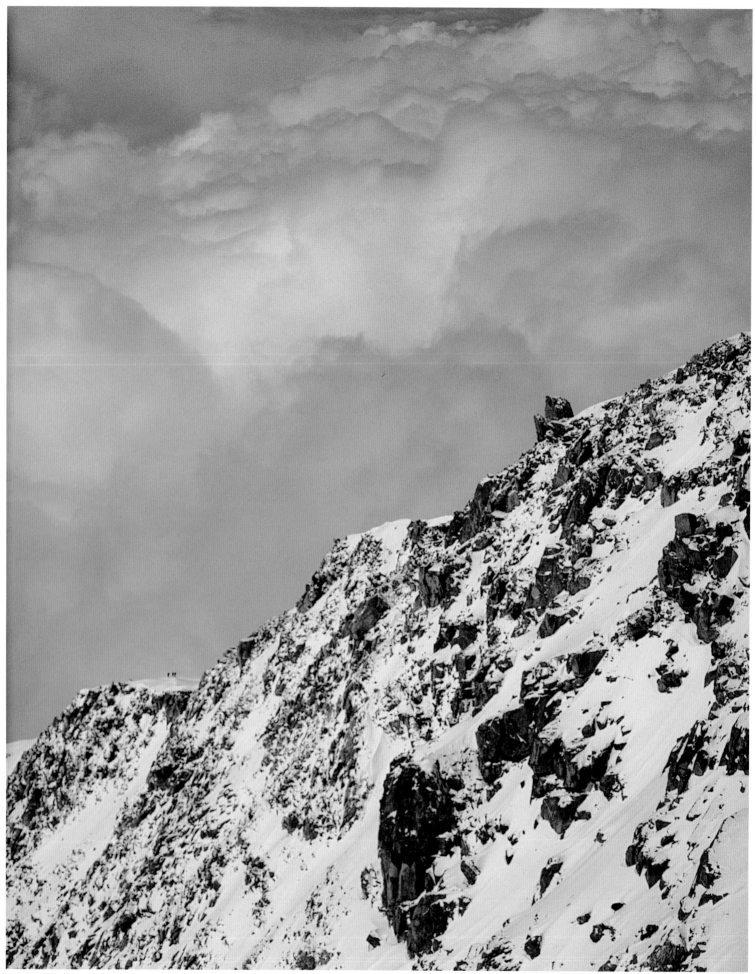

INTO THIN AIR – A climbing party ascends the steep and rocky ridge that connects the crest of the West Buttress at 16,000 feet and high camp at 17,200 feet.

"Climbing Denali is an amazing lesson in living in the moment when your whole world, your whole reality collapses down into the single breath you are taking right now, and the step that follows it." **KEVIN MAXWELL**

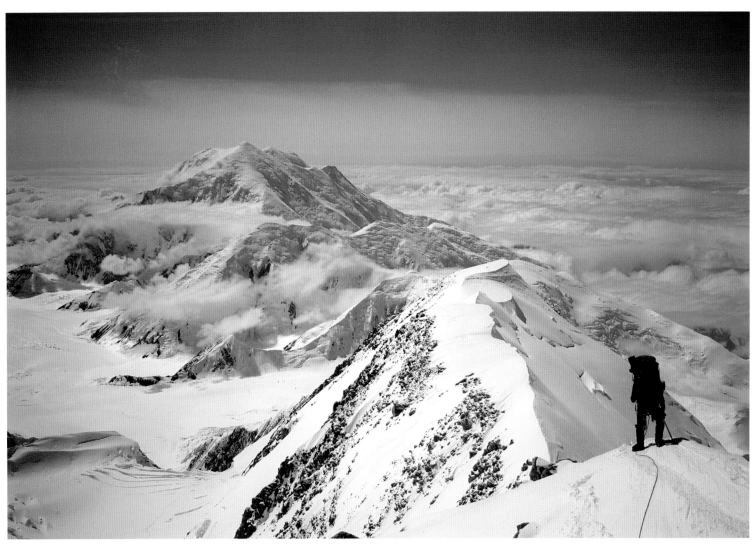

BREATHE DEEP – Michael Engelhard of Canada climbs high on Denali's West Buttress. Oxygen deprivation is a problem above 18,000 feet where the ambient oxygen content is less than half of what it is at sea level.

"You have to want to do it really badly. You can be as strong as the best athlete, but if you don't have the mental drive to climb at altitude, your body will just say 'let's go home'. And you will go home." **DIANE CALAMAR OKONEK**

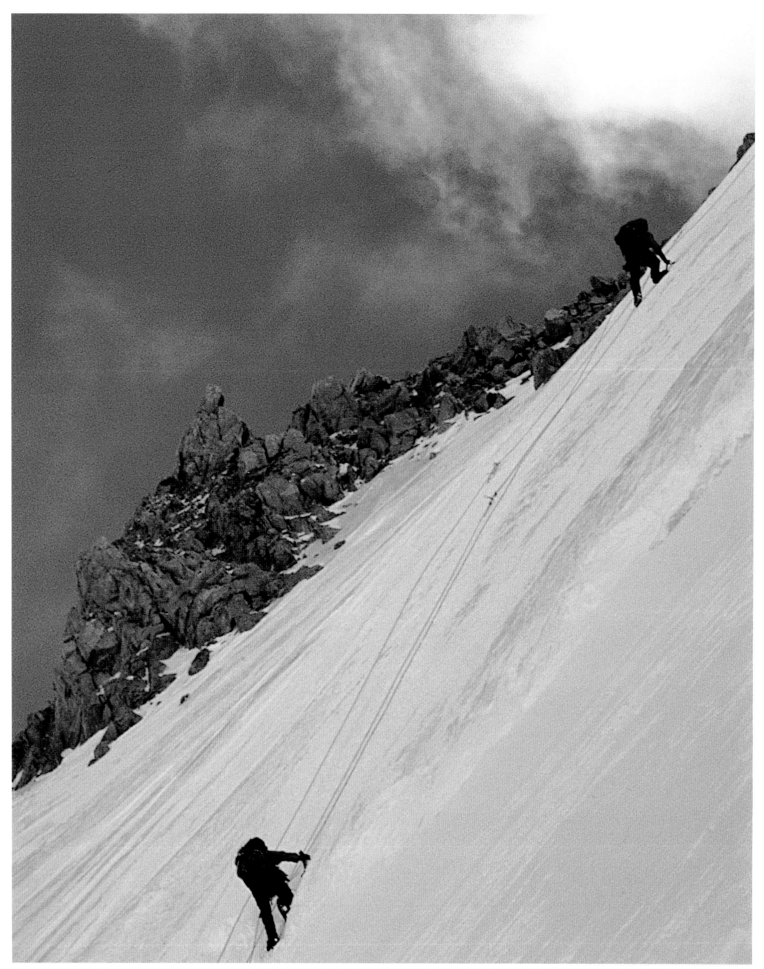

CLIMBING AID – Ropes are permanently anchored in the ice to help climbers ascend and descend the Headwall, the steepest section of the West Buttress between 15,500 and 16,000 feet.

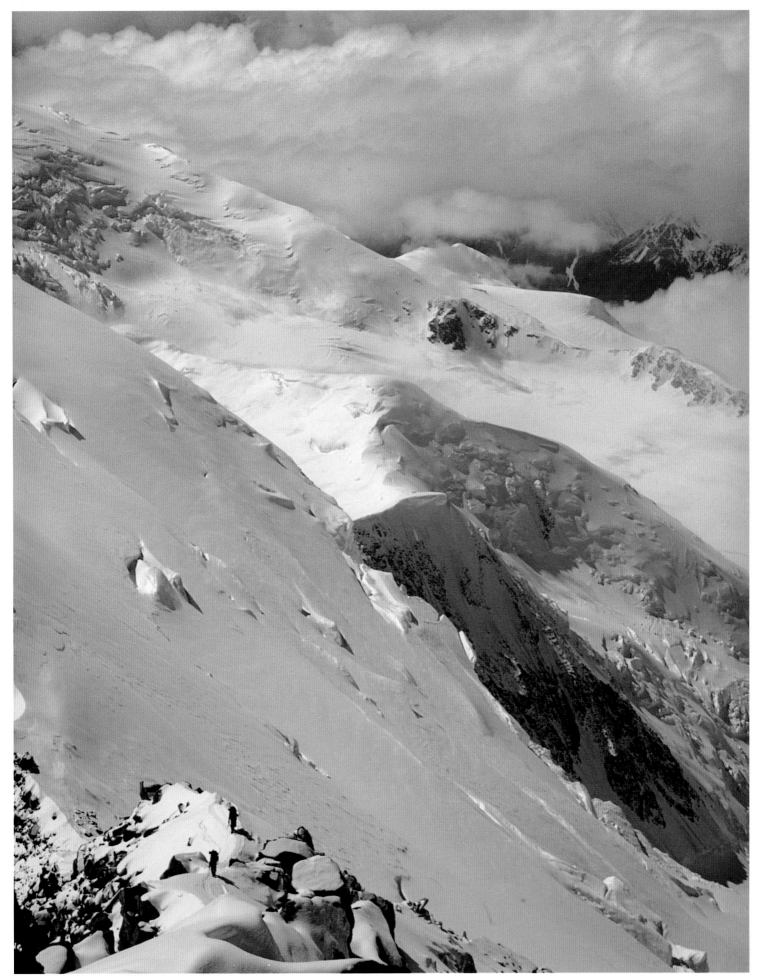

LONELY FIGURES – Climbers are swallowed up in a vast expanse of rock, snow and sky near 16,200 feet on the West Buttress.

Summit

SUMMIT SONG – Mountain guides Vern Tejas of Anchorage, Alaska and Marty Raney of Wasilla, Alaska play a bluegrass tune on Denali's summit.

"It's like breathing through a straw. Up high, you never get enough oxygen. On the summit ridge, I have taken six or seven breaths for each step. Just making 300 yards can be a half-hour adventure." **KIRBY SENDEN**

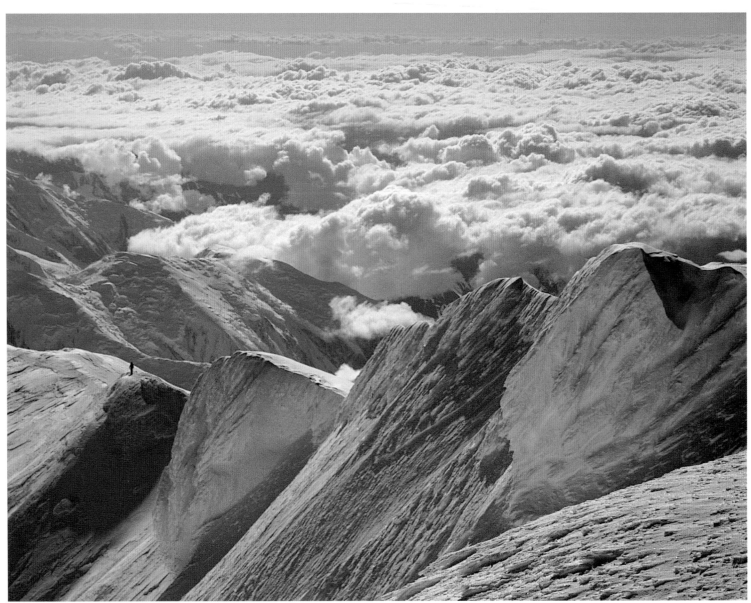

FINAL PUSH – A climber ascends the last 200 vertical feet of the ridge leading up to the summit.

"The day I went up to the summit was the most physically challenging experience of my entire life. Being consumed in that physical drama took away from the opportunity to look around and appreciate where I was." **KEVIN MAXWELL**

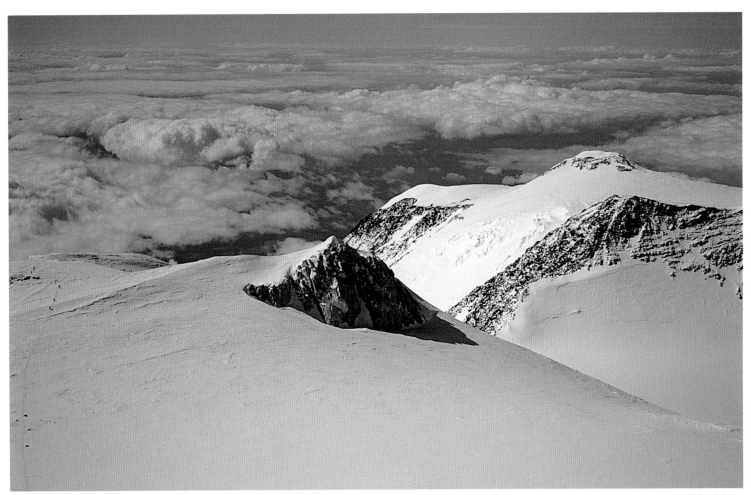

ONE STEP CLOSER – Roped teams climb past Archdeacon's Tower. The 19,650-foot-high tower is named after Archdeacon Hudson Stuck, the Episcopal minister who led the first successful party to Denali's summit in 1913.

"The summit gives you the excuse to go to the mountains, but the whole adventure can be a very satisfying learning experience whether you go to the top or not." **BRIAN OKONEK**

"We all may define success in different ways, but ultimately an expedition is only successful if my teammates and I make it home safely." **LAURENT DICK**

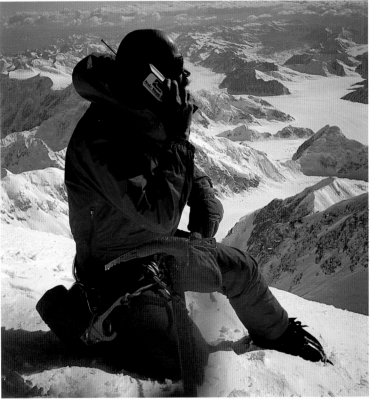

SHARING THE SUMMIT – Mountain guide Vern Tejas of Anchorage, Alaska celebrates reaching the summit with a call on his cell phone.

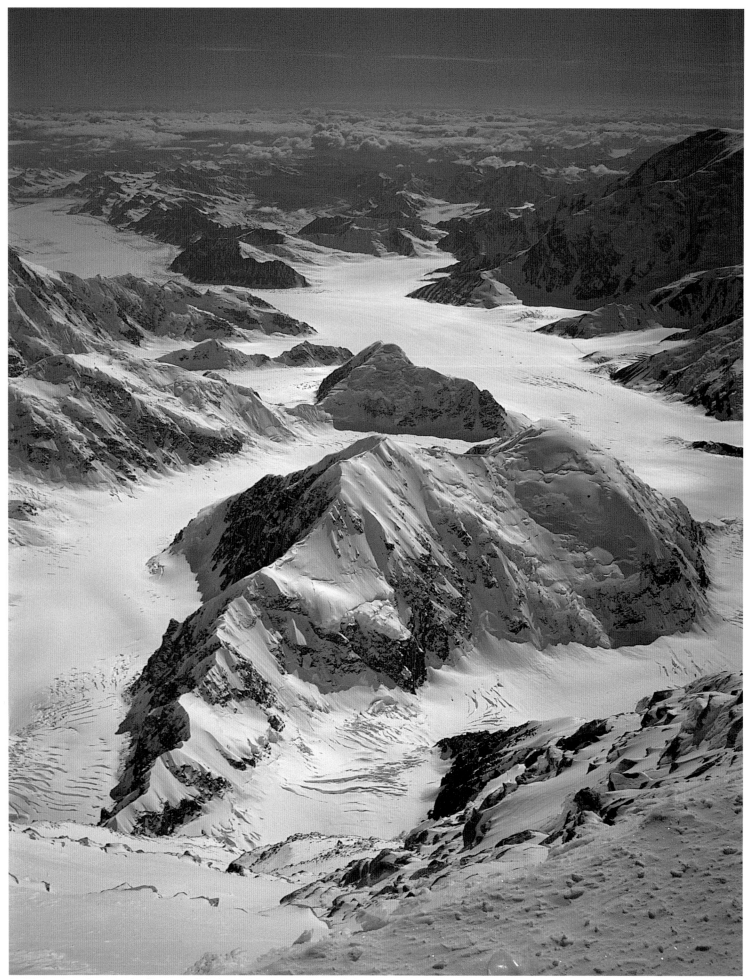

RIVER OF ICE – The summit offers splendid views of the 41-mile-long Kahiltna Glacier, the largest in the Alaska Range.

"I could see for hundreds of miles in each direction. But foremost on my mind was the descent. We had to stay sharp, couldn't let our guard down." **LAURENT DICK**

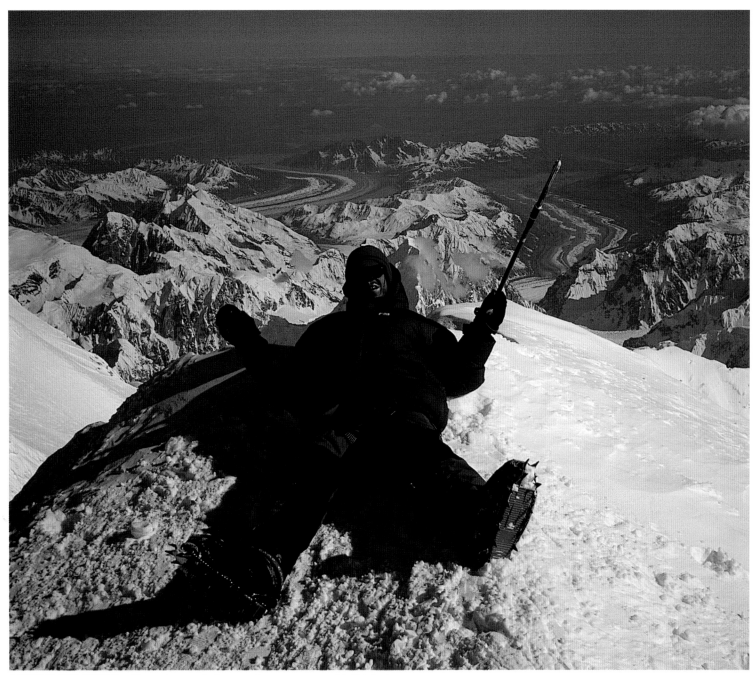

SAVORING THE SUMMIT – The author revels in a precious moment at 20,320 feet.

"The chance for something to go wrong is highest on a summit push. People sometimes underestimate how hard it is to come back from the summit. They use most of their energy to go to the top, and when they are descending, balance and strength are gone. Eighty-five percent of all accidents on Denali happen during the descent, usually after a summit push. If people get mixed up in their priorities, and the summit becomes the priority, as opposed to self-sufficiency, that's when accidents will happen." **DARYL MILLER**

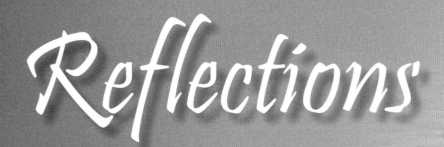

Reflections

SLEEPING VISTA – A climber rests at 16,000 feet on the West Buttress, gazing at a sea of clouds to the north and west.

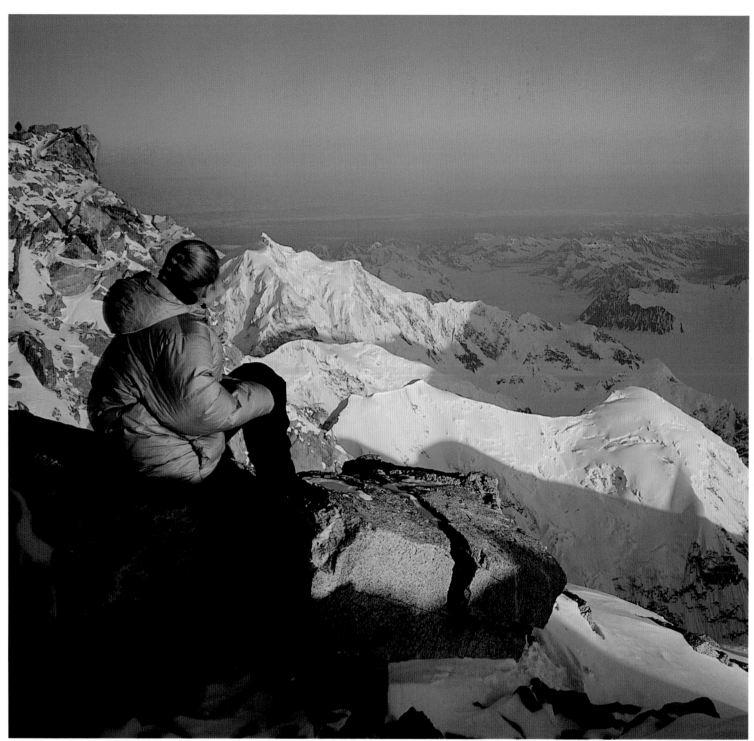

EVENING TRANQUILITY – Tiffany Hanson of Talkeetna, Alaska and a raven enjoy a peaceful evening at 17,200 feet on the West Buttress.

"We stopped and everybody just sat down. Nobody said a word. It was absolutely dead quiet. There was not a breath of wind and I think we all kind of melted into the snow and became part of the mountain." **KIRBY SENDEN**

"The time we spent on Denali was almost utterly controlled by the geography. There's seldom in life a time or opportunity for our life to be so dictated by the lay of the land. The routine of the day is so much a function of the shape of the mountain and the weather that the mountain creates." **KEVIN MAXWELL**

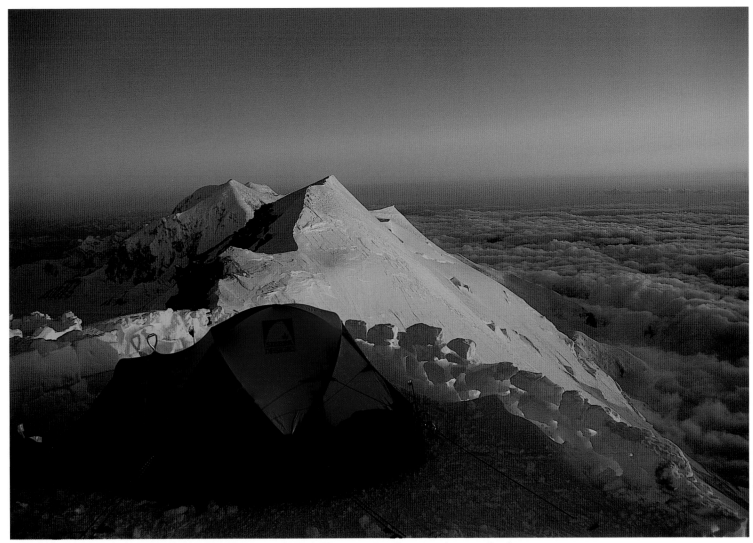

NO VACANCY – The narrow ridge camp at 16,200 feet on the West Buttress only offers room for a couple of tents.

"The mountain is very much alive. I feel her presence when I wake up in the morning, and when I start climbing, I always feel there is something else with me. At night, when I zip up the tent, I know that I am on something that is alive." **KIRBY SENDEN**

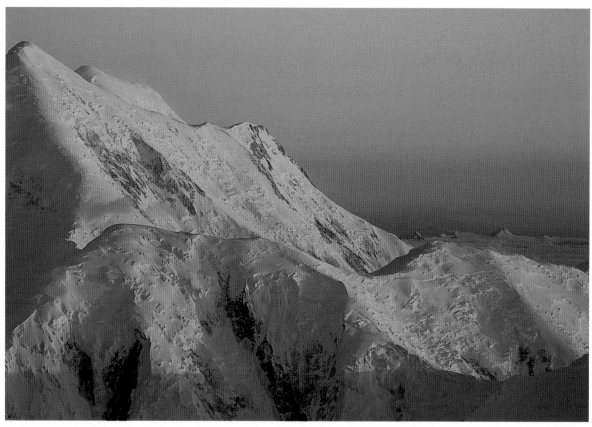

MOVEMENT OF LIGHT – Late evening sun hits the east and north flanks of 17,400-foot Mount Foraker, the second highest peak in the Alaska Range.

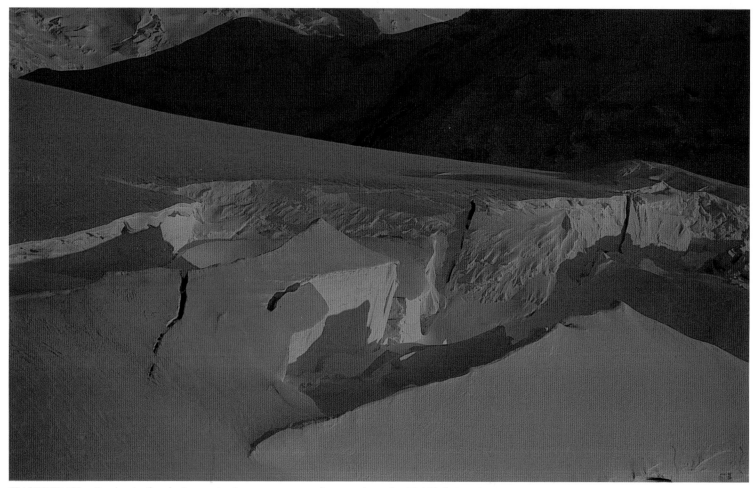

FRACTURED ICE – Tension in the glacier creates huge crevasses and seracs above the 11,000 foot camp.

"We are all so ephemeral that in a moment, a life can cease to exist. Our grasp on life is only as good as the strength of the rope we are tied to, or in the competence of our partner, or the warmth of our clothing, or the quality of our judgement." **KEVIN MAXWELL**

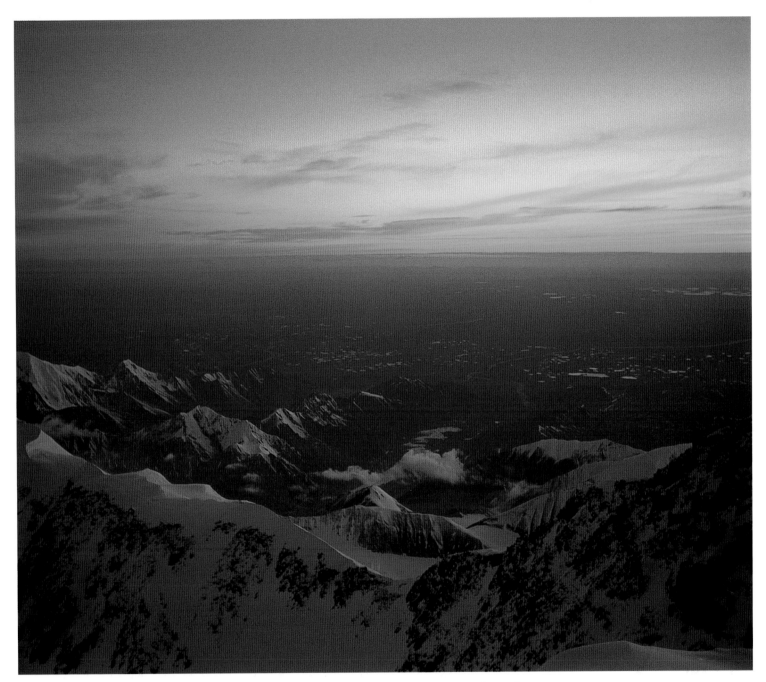

LOFTY VIEW – The panorama from the 17,200-foot camp includes sweeping vistas of the tundra to the north.

"You have to make peace with death. Accepting and coming to terms with it is important when you climb. In our society, we often push it off. On the mountain, you see how precious life is, you enjoy every day as a wonderful day." **CONRAD ANKER**

MIDNIGHT REVELATION – The midnight sun bathes the northern slopes of Mount Hunter in a warm glow at 2 a.m.

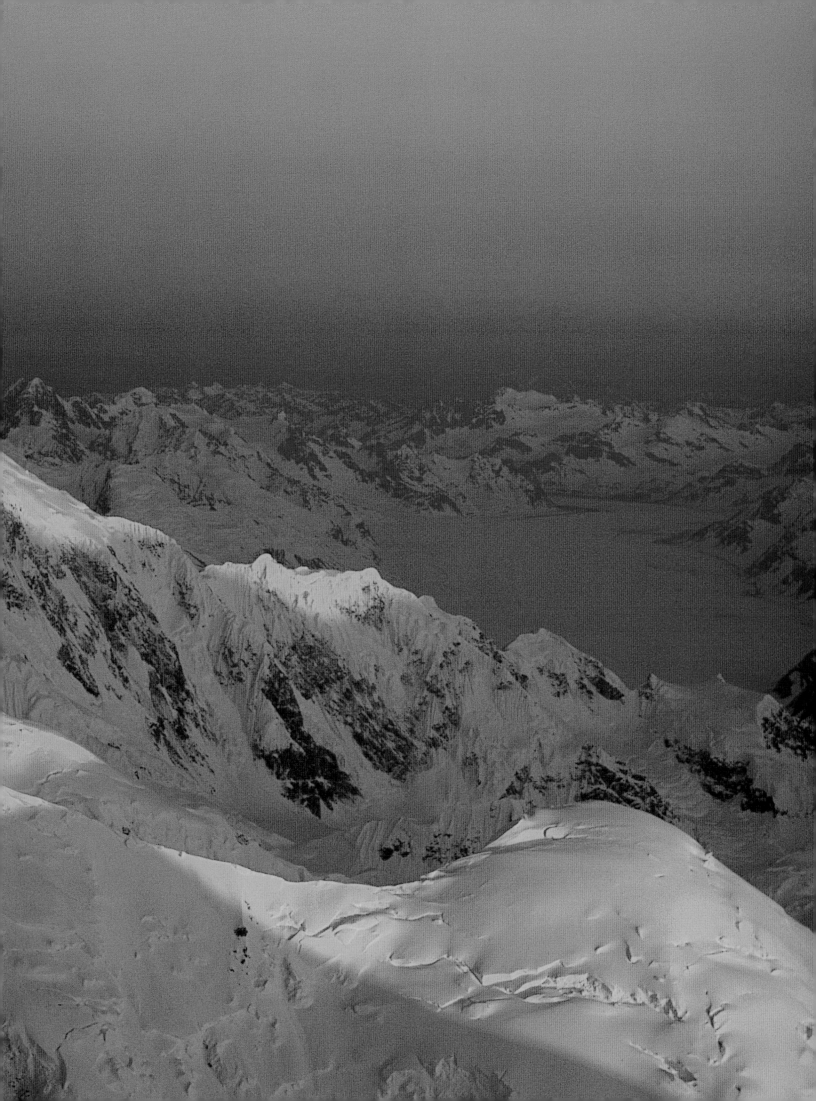

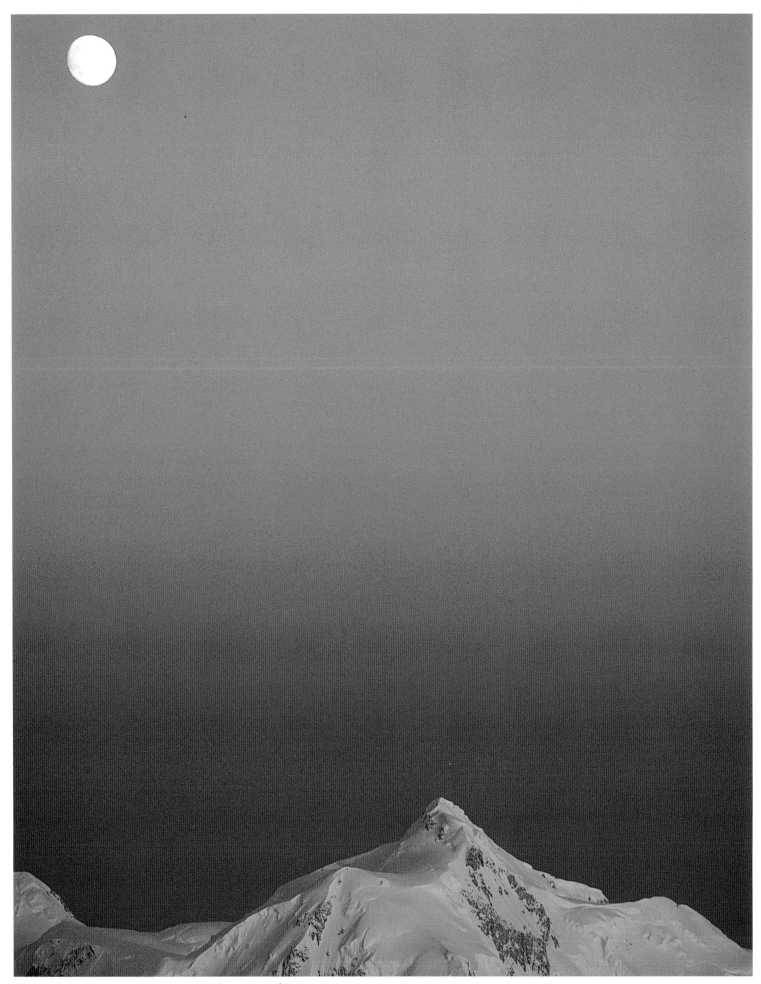

CELESTIAL DANCE – A waxing moon rises above 14,570-foot Mount Hunter.

*"Climbing Denali gives good perspective on what life is all about
and what your place in life is."* **JOANNA COCKMAN**

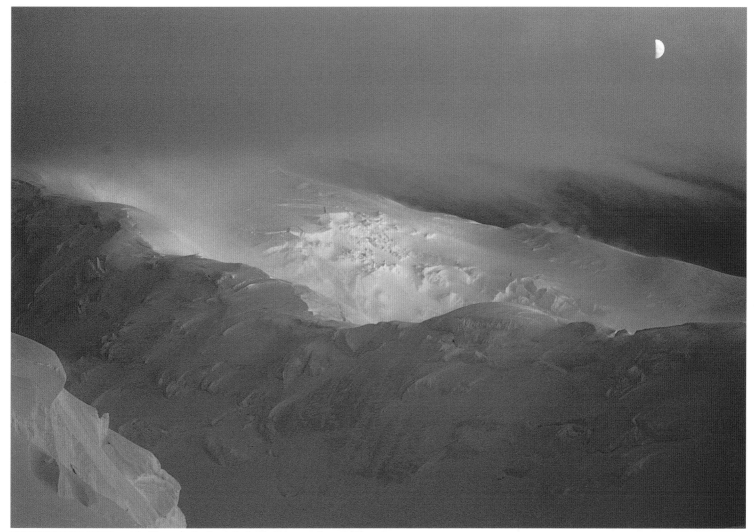

EVERCHANGING LIGHT – A half-moon slowly sinks behind 12,525-foot Kahiltna Dome.

*"The aura of being in a place that is so naturally majestic draws me to high mountains. Whether
it is on a side of a sheer rock face or on a broad snow slope, looking around at morning or
evening light, or a brilliant moon rising — your body feels healthy and you think, wow, there's
no other place in the world I would rather be. This is it. This is why I am here."* **JOE REICHERT**

"However, each of us "climbs mountains" in our very own separate ways...in our work, our relationships, our play. These efforts are no less real, hazardous, or rewarding than climbing among high mountains. We reach for an unseen – often unidentified – but deeply felt life quality. We break though and find joy." **PAUL HWOSCHINSKY**

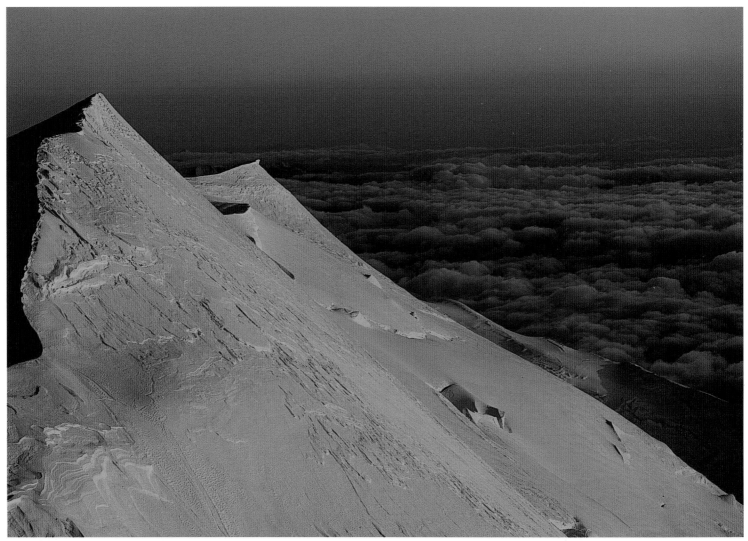

ALPENGLOW – September light boldly illuminates the 16,000-foot crest of the West Buttress in mid-June.

"Denali invites hope for tomorrow — a place so spectacular it has the power to change peoples' perspective of the world just by seeing it for the first time." **WILLIE KARIDIS**

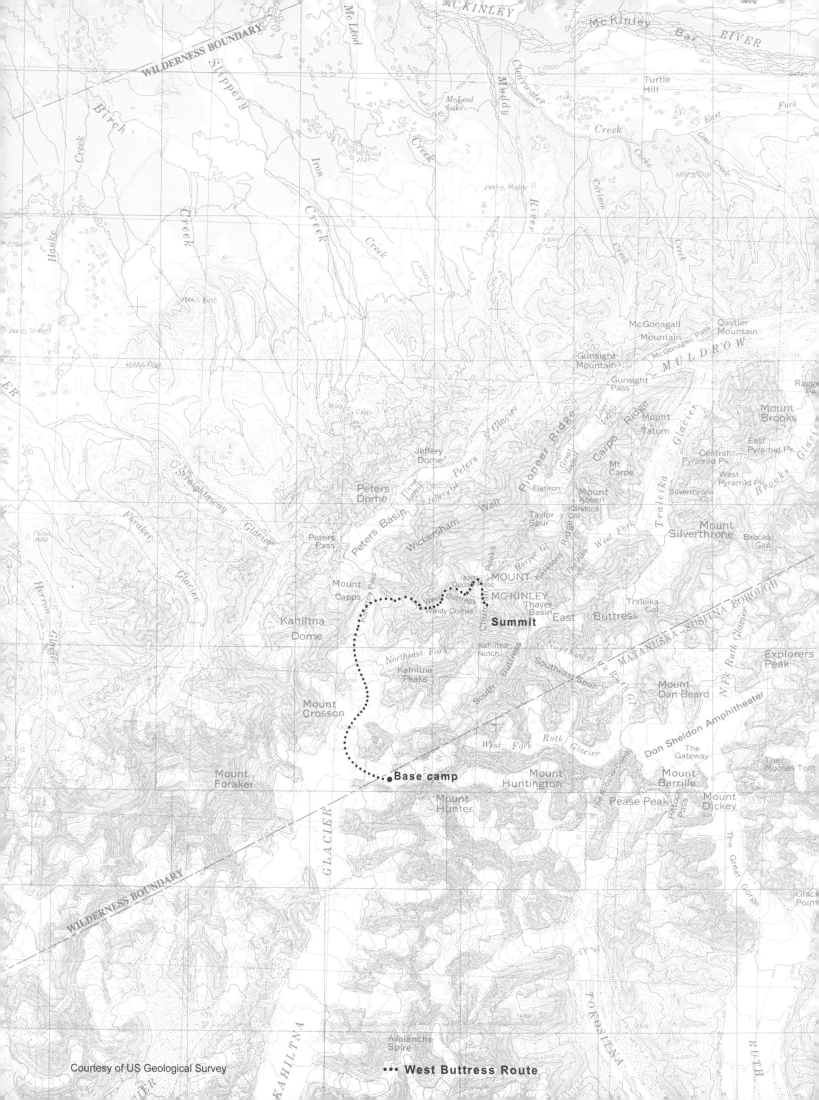

••• West Buttress Route